GEO

D0250173

'06

WOMEN &
DOGS

A Personal History from
Marilyn to Madonna

JUDITH WATT & PETER DYER

ATRIA BOOKS
New York London Toronto Sydney

For Ludwig, Hettie, and the late Beattie, a truly great bull terrier

ACKNOWLEDGMENTS

We are grateful to the numerous friends and acquaintances who provided information and suggested avenues of inquiry, in particular Maia Adams, Janine Button, Basil Comely, Jilly Cooper, Jillian Edelstein, Daisy Garnett, Margaret Halton, Oriel Harwood, Jessica Hayns, Gavin Houghton, Nigel Jenkinson, David Kappo, Lucinda Lambton, Ruth Marshall-Johnson, Robin Muir, Lawrence and Anthea Mynott, Vanessa Nicolson, Toby Rose, Paul Simpson, Philippa Stockley, Marketa Uhlirova, Ann Verney, Angus Watt, Shona Watt, Tristan Webber, Jo Weinberg, and Harriet Wilson. The London Library, Kennel Club, and Dogs Trust have also been invaluable; and a special thank-you goes to Katy Hart and Fiona Healey-Hutchinson at Battersea Dogs & Cats Home, to the sterling staff of the Condé Nast Library in London, and to Cathie Arrington. Last, but not least, thank you to Mark and Nat at Sort Of Books, and to Ray Holland. And welcome to the wonderful world of dogs.

1230 Avenue of the Americas
New York, NY 10020

Copyright © 2005 by Judith Watt and Peter Dyer

Published by arrangement with Sort Of Books

Originally published in Great Britain in 2005 by Sort Of Books

All rights reserved, including the right to reproduce
this book or portions thereof in any form whatsoever.
For information address Atria Books, 1230 Avenue
of the Americas, New York, NY 10020

Individual photographs © the rights holders detailed on p. 160. Every effort has been made to contact the correct copyright holders.

Library of Congress Cataloging-in-Publication Data
Watt, Judith.
 Women & dogs : a personal history from Marilyn to Madonna / Judith Watt & Peter Dyer.
 p. cm.
 Originally published: London : Sort Of, 2005.
 Includes bibliographical references.
 1. Celebrities—Portraits. 2. Portrait photography.
 3. Photography of women. 4. Photography of dogs.
 I. Dyer, Peter. II. Title.
TR681.F3 W38 2006
779'.2—dc22 2006040711

ISBN-13: 978-0-7432-8843-9
ISBN-10: 0-7432-8843-2

First Atria Books paperback edition June 2006

10 9 8 7 6 5 4 3 2 1

ATRIA BOOKS is a trademark of Simon & Schuster, Inc.

Manufactured in Italy

For information about special discounts for bulk purchases,
please contact Simon & Schuster Special Sales:
1-800-456-6798 or business@simonandschuster.com.

WOMEN & DOGS

Frida Kahlo with one of her Mexican hairless dogs, 1936

The iconic Mexican artist Frida Kahlo (1907–1954) is pictured here at the Blue House in Mexico City with an escuincle, a classic Mexican breed revered by the Aztecs. Like her adoption of traditional costume, these dogs were an assertion of Kahlo's Mexican identity. In Aztec culture, if the rains failed and there was a drought, escuincles would be sacrificed to appease the gods. Great processions would conduct them, carried in highly decorated litters, to a place sacred to the rain god. Here their hearts would be cut out while they were alive, and their bodies cooked and eaten at the parties that followed.

Kahlo was a great animal lover, and her menageries included monkeys, cats, parrots (one would famously drink tequila and screech, "I can't get over this hangover"), a deer, and an eagle. She was married twice to the Mexican artist Diego Rivera, a relationship punctuated by affairs on both sides, with Frida involved with several women (Georgia O'Keeffe, reputedly, among them). While Rivera turned a blind eye to his wife's lesbian liaisons, he was less sanguine about the other men in her life, which included, in 1935, the artist Isamu Noguchi. After Rivera heard of their affair, Kahlo and Noguchi had a secret assignation at her sister's house; however, Rivera showed up when the couple were in bed. Noguchi hurriedly put on his clothes and fled, but one of her dogs naughtily seized a sock and ran off with it; Rivera, finding it, went after Noguchi with a gun.

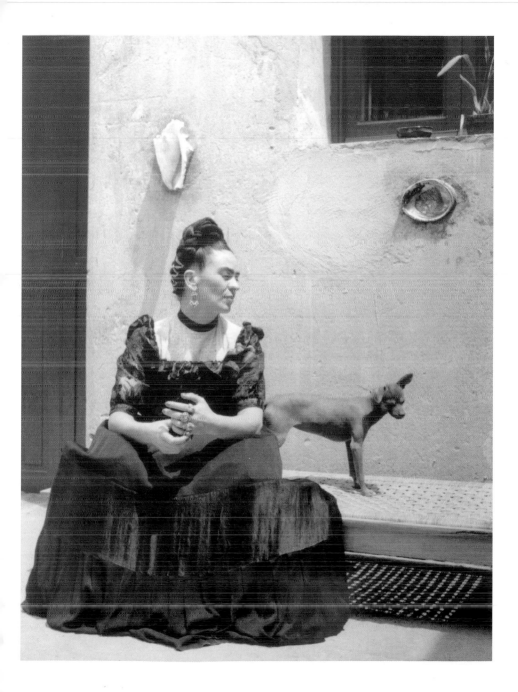

Ingrid Bergman with an Airedale puppy, 1942

This is a classic 1942 shot of Ingrid Bergman (1915–1982): a happy, wholesome image, holding the family puppy at the Hollywood home she shared with her husband, dentist Peter Lindstrom, and their daughter, Pia. It had been a major year for the actress: *Casablanca*, in which she played Ilse opposite Humphrey Bogart's Rick, had been released to the acclaim of wartime audiences, and she had started work on *For Whom the Bell Tolls* (1943), playing Maria opposite Gary Cooper in the film of Hemingway's Spanish Civil War novel. Bergman, who was brought up in Sweden, moved to Hollywood at the outset of the war in 1939, and was adopted as an icon of feminine wholesomeness. By the war's end, she was Hollywood's leading female star; however, in 1948 all this changed when she worked with Roberto Rossellini on the film *Stromboli*. Each was married to someone else, but they had an affair, and a child. Bergman became an outcast, denounced in the American press as a "free love cultist" and an "apostle of degradation." The couple moved away to Italy, where they had twins, Isabella and Isotta, and Bergman never worked again in the United States.

Dogs seem to have always played a role in Bergman's life. Her daughter Isabella Rossellini recalled a French bulldog her parents owned, named Stromboli; Youpi the Maltese, who reared kittens until she had her own puppies; and Nando, Isabella's own dachshund, who lived to be nineteen. After Bergman was divorced from Rossellini in 1957, she lived in Choisel, near Paris, adding Agrippa, a black Belgian sheepdog, to the household. In her final years, she shared her home with a "horrible mutt" named Bobby, who belonged to her last husband, Lars Schmidt.

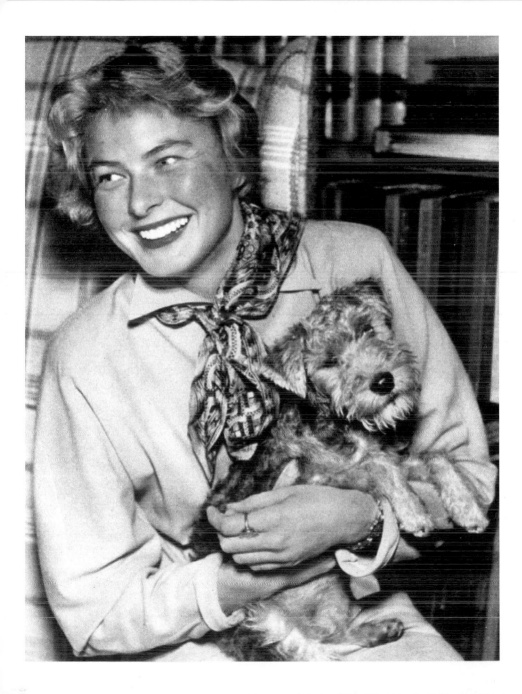

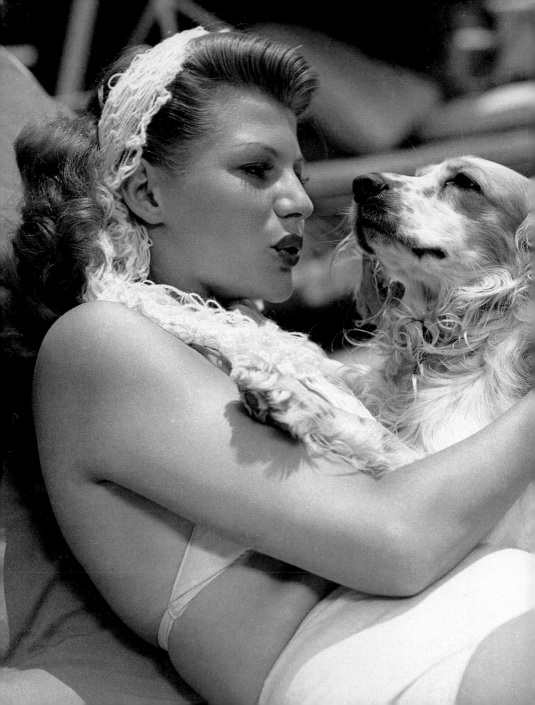

Rita Hayworth with her spaniel, **Pookles**, c. 1946

"Love goddess" Rita Hayworth (1918–1987) posed for this Hollywood publicity shot with her own spaniel, Pookles. At the time, she was married to Orson Welles and was at the height of her fame as the femme fatale in *Gilda* (1946). The white and gold cocker spaniel puppy was a present from Welles's surrogate father, Dr. Maurice Bernstein, who was aware that the star, pregnant with her first child, was growing lonely while Welles was off on the East Coast, pursuing a political career. Pookles was the nickname Bernstein gave to Welles, and was her daughter Rebecca's first word—more likely referring to the dog than to her often absent father. Hayworth and Welles divorced in 1946, the actress subsequently marrying Prince Aly Khan, father of the present Aga Khan.

Radclyffe Hall with a Boston terrier, 1930

When Radclyffe Hall (1880–1943) met her partner, Lady Una Troubridge, Hall was accompanied by a toy fox terrier named Jill—an "unsatisfactory little beast," wrote Troubridge in *The Life and Death of Radclyffe Hall*, but "dogs . . . she was never without." Hall published her controversial novel of Sapphic love, *The Well of Loneliness*, in 1928, and when it was banned in Britain, she and Troubridge became celebrity lesbians, derided and acclaimed—Hall wearing masculine clothes, cloaks, and fedoras, and Lady Una a monocle. A competitive pair, they were well known for their "thoroughbred" dogs, breeding champion smooth-haired dachshunds as well as Boston terriers, griffons, and Brabançons at their Fitz-John Kennels, a converted drawing room at their home, Chip Chase. Olaf the Great Dane, Tulip the Brabançon, and Rufus the faithful sable collie from Battersea Dogs & Cats Home were all favorites, as was Fido, an "outsize white poodle" rescued in Florence and transported back to Britain. "He was as clever as he was loving," and was well known in Florence, where he would sit upright on a chair beside his mistress at Doney's tearooms, occasionally putting one paw on the table, at which a waiter would bring two sponge fingers *"per il signorino."*

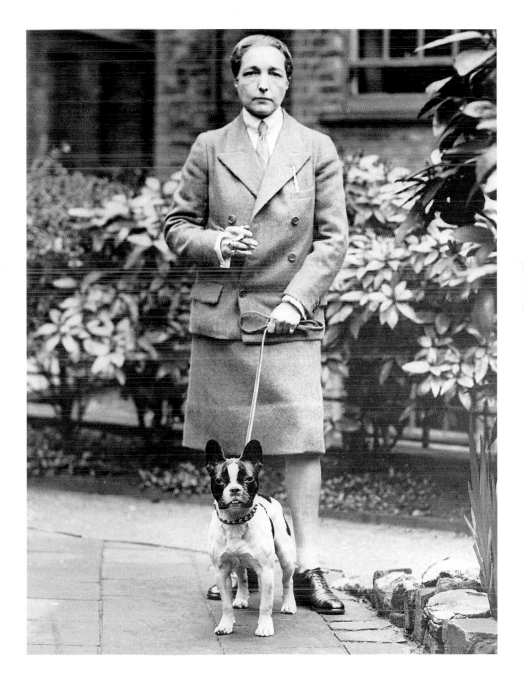

Sarah Jessica Parker with **Sweetie**, 2000

Sarah Jessica Parker (born 1965) poses with a dog named Sweetie dur-
ing a break in filming the hugely popular TV series *Sex and the City*, in
which she plays Manhattan sex columnist Carrie Bradshaw. In real life,
Parker and her husband, actor Matthew Broderick, have a border collie
named Sally. Broderick bought Sally in 1991 for $35 from a farmer who
was selling her on a northern California highway, and her herding
instincts are those of a real country dog. Sally practiced her rounding-up
skills on the streets of New York City by herding rats into their holes until
Broderick broke her of the habit and got her to fetch Frisbees instead. So
obedient is Sally that her trainer, the well-known Bash Dibra, featured
her in one of his training videos. Parker played the lead role of a (talking)
stray dog who takes over a household in the off-Broadway production of
A. R. Gurney's *Sylvia*, and modeled herself on Sally. "I've never seen a dog
portrait in films or on the stage that quite matches the truth and wit of
Ms. Parker's performance," said *The New York Times*.

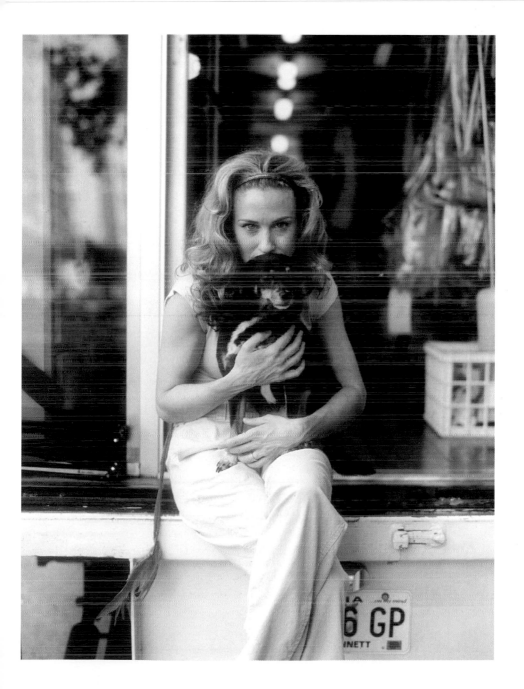

Marilyn Monroe with **Hugo**, her basset hound, 1956

"Dogs never bite you. Just humans," observed Marilyn Monroe (1926–1962), who kept dogs and other animals throughout her life. When she was engaged and then married to playwright Arthur Miller, she had this basset hound, Hugo. He was an apartment dog, living with the couple on East Fifty-seventh Street in New York City, where he would listen to Monroe practicing "I Want to Be Loved by You" on the ukulele. This photograph was taken shortly before Miller and Monroe's wedding; the playful posing belies the fact that Miller, branded as a communist sympathizer, was being called before the House Un-American Activities Committee, and the loyal Monroe was also branded a pinko. The marriage lasted until 1960, when Miller left Monroe but kept Hugo. Frank Sinatra promptly gave Monroe a white toy poodle, which she named Maf, short for Mafia, an allusion to Sinatra's mob connections. The dog was photographed after Monroe's death, looking distressed amid the crowd of police and reporters; it was subsequently adopted by Sinatra's secretary.

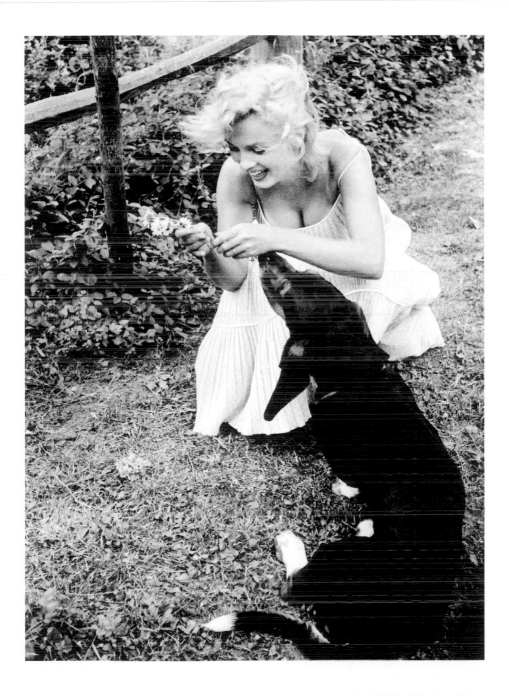

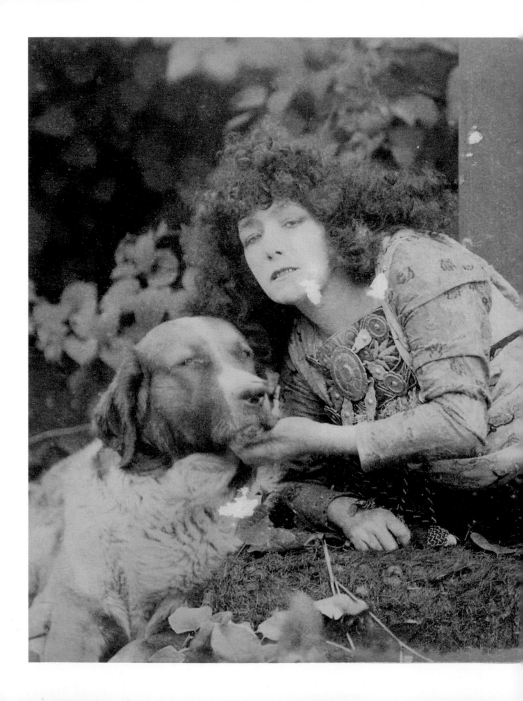

Sarah Bernhardt with a Newfoundland-type dog, 1894

Few other figures in theater approach the great Sarah Bernhardt (1844–1923). She was, throughout her life, a sensation: an actress acclaimed in Britain and America as much as in her native France, and an eccentric of consummate style, keeping pet lions and sleeping in a coffin. Here, the New York photographer Napoleon Sarony shows her playing the title role in *Leah the Forsaken*, a play about a noble Jewish martyr, Bernhardt's gravitas nicely complemented by this large dog. The dog was probably her own, for Bernhardt was an inveterate dog owner, as well as keeping monkeys, parrots, and a whole menagerie of animals. In her autobiography, *My Double Life* (1907), she describes how, in 1879, while playing in London, she traveled to Cross's Zoo in Liverpool to buy some pet lion cubs. Mr. Cross knew that she liked animals, as he had already sold her three dogs: "Had it not been for a gentleman who was with you, you would have bought five." There were no cubs for her, so she bought a young cheetah "and a dog-wolf [probably a husky], all white with a thick coat, fiery eyes and spear-like teeth," Cross throwing in some chameleons for good measure.

Veronica Lake and an Old English sheepdog, 1941

Veronica Lake (1919–1973), the diminutive star of Preston Sturges's classic screwball comedy *Sullivan's Travels*, had Hollywood's most distinctive hairstyle of the 1940s. The peekaboo bang—a wave brushed across her right eye—provided the iconic image for a string of wartime movies, and the public loved it. So much so, in fact, that in 1943 U.S. military officials asked her to make an industrial safety film, as women were copying her and getting their hair caught in assembly-line machinery. But this innocent publicity still—a photo opportunity waiting to happen—predates Pearl Harbor and was issued by Paramount to boost her image. Lake seems at ease posing with an Old English sheepdog, and indeed was a dog fancier herself, keeping racing greyhounds in later life. She had by then left Hollywood; Paramount ended her contract in 1948 after throwing her in to "rescue" a slew of second-rate movies. Post-Hollywood, Lake struggled to find work, and had bouts of alcoholism, succumbing to an early, sad death from hepatitis. Still, her reputation endures through Sturges's film, and many years later she provided the inspiration both for the cartoon femme fatale Jessica Rabbit and for Kim Basinger's Lynn Bracken, the Veronica Lake look-alike prostitute in the film adaptation of James Ellroy's *L.A. Confidential*.

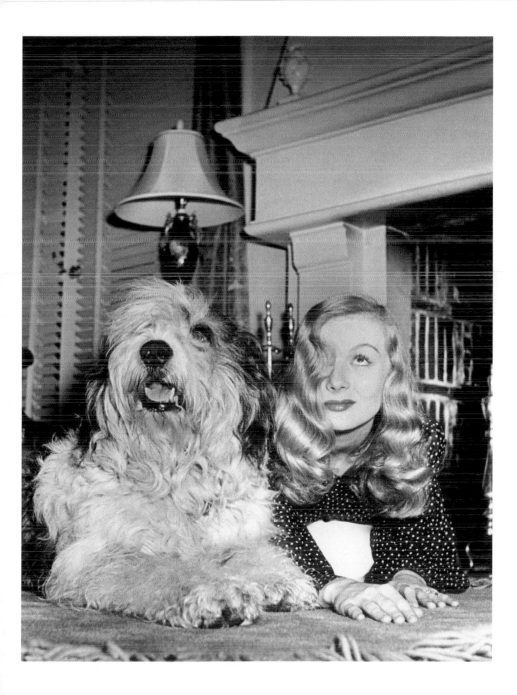

Jacqueline Kennedy and her family with **Clipper** the German shepherd and two "Pupniks," 1963

According to Traphes Bryant, the presidential dog keeper, in *Dog Days at the White House*, the Kennedys were showered with dogs almost from the moment JFK took office. They already had a dog, Charlie the Welsh terrier, and soon he was joined by Pushinka, a spitz-type dog, given to their daughter, Caroline, by Soviet leader Khrushchev. Charlie and the snappy Pushinka (daughter of the Russian space dog Strelka) produced a litter of pups that the Kennedys referred to as "Pupniks." Then came Clipper, the beautiful German shepherd in this family picture, who was a gift to Jacqueline from her father-in-law. He was followed by Shannon, a cocker spaniel, presented by Eamon De Valera, the Irish prime minister, and by Wolf, an Irish wolfhound. Charlie was top dog, slept where he liked, and dominated the pack. After the president's assassination, Jacqueline Kennedy (1929–1994) gave away all the dogs except Shannon. She made it clear, says Bryant, that she did not want the expense or trouble.

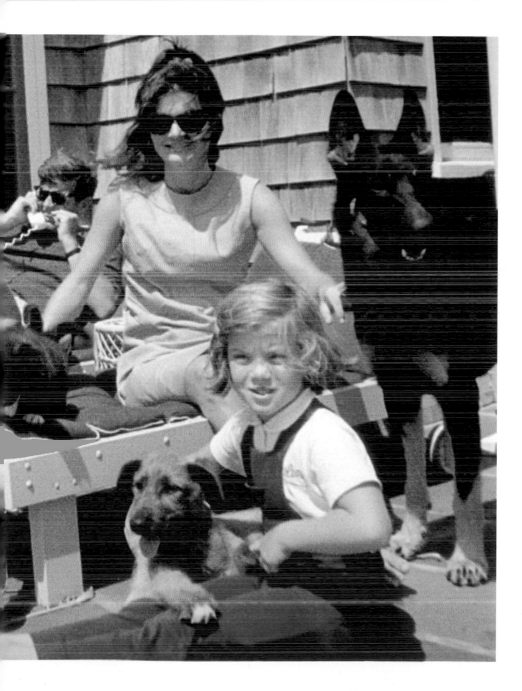

Queen Victoria and her collie, **Sharp**, 1866

One of the first things that Queen Victoria (1819–1901) did when she came to the British throne in 1837 was to become the patron of the Society for the Prevention of Cruelty to Animals. Cruelty to animals was, she thought, "one of the worst traits in human nature," and this concern set an example for the British, who until her reign were not known for their kindness to other species. Victoria, however, had a legendary passion for dogs, starting with her King Charles spaniel, Dash, and ending with Pomeranians called Marco and Janey, her favorites among the eighty-eight dogs in the royal kennels when she died. Dachshunds were her preferred breed in the late 1840s and through the 1850s, but in the 1860s she developed a love of collies, a breed she associated with the Scottish Highlands and Balmoral. These collies were the early versions of the rough-coated and smooth collies we see today, albeit blunter nosed and smaller. Sharp (1864–1879), the subject of this photograph, was particularly loved. He appears at the feet of Victoria's personal servant, John Brown, in Sir Edwin Landseer's painting *Queen Victoria at Osborne*, and the dog was also painted by Charles Burton Barber.

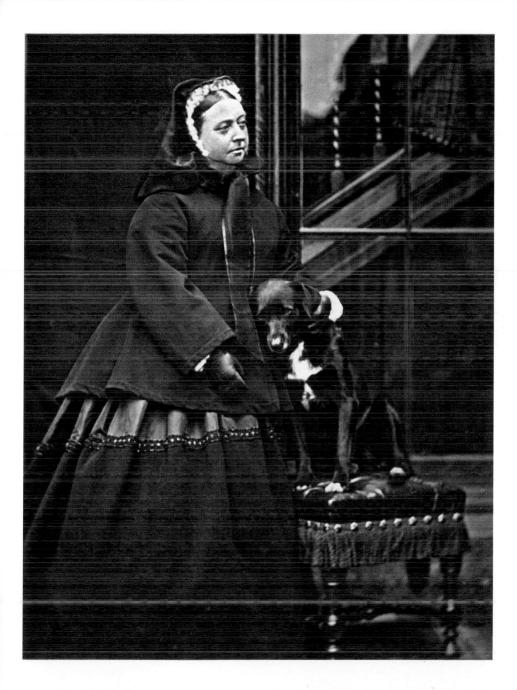

Storyville prostitute with a puppy, c. 1910

The name of this young prostitute teaching a little lapdog to sit up and beg is unknown, but she was photographed by E. J. Bellocq (1873–1949) in one of the small yards outside one of the many brothels that made up New Orleans's Storyville district. Mythologized as a Toulouse-Lautrec figure, Bellocq was a short man with a hunchback and a facial deformity. He began photographing the Storyville brothels in 1902, after his mother had died, along with a second project (now, sadly, lost) documenting the opium dens of the Chinatown district. Bellocq must have cut quite a figure, wearing monogrammed jewelry and sporting a signature red neckcloth, but one of his sitters in the brothels remembered that "he always behaved polite." So private was his Storyville project, however, that it was only half a century later, when the glass negative plates were discovered in a junk shop and printed by the photographer Lee Friedlander, that this valuable archive became known. In 1970, the Museum of Modern Art in New York presented a retrospective, and Bellocq became a name in photographic history—and the inspiration for Louis Malle's film *Pretty Baby*.

Janis Joplin with her collie cross, **Thurber**, 1968

Janis Joplin (1943–1970), the great female rock singer, was often seen chauffeuring her dog Thurber around San Francisco in a customized 1965 Porsche cabriolet. Joplin had named the collie cross after the irreverent American writer and cartoonist James Thurber, whose funny and affectionate stories about dogs were among her favorites. Thurber poses beautifully in what was a series of photographs of Joplin; other images show her walking him on a leash. She had moved to the liberal, hippie haven of San Francisco from Austin, Texas, in 1966 and was fronting Big Brother and the Holding Company when she bought the car in 1968. She had it painted by her friend Dave Richards, the Big Brother roadie, and it featured psychedelic landscapes, a portrait of the band, and a bloodied American flag in protest against the war in Vietnam. Janis Joplin and Big Brother had hits with "Piece of My Heart" and "Summertime" but split at the end of that year. Joplin went on to a solo career, recording her unique white blues. She died of an accidental heroin overdose in 1970, and her finest album, *Pearl*, featuring her classic songs "Me and Bobby McGee" and "Mercedes-Benz," was released posthumously.

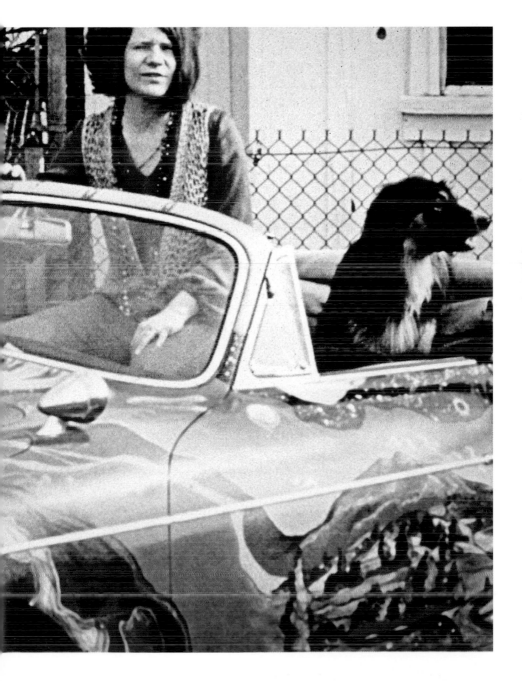

Edith Cavell with her dogs, **Don** and **Jack**, 1915

Edith Cavell (1865–1915) was matron at the Berkendael Medical Institute, a training school for nurses outside Brussels, when this photograph of her with her adored dogs—Don the lurcher and Jack the collie— was taken in the institute's garden. The daughter of a Norfolk vicar, Cavell had moved to Belgium in 1907, and she had worked as a governess before becoming a redoubtable nurse and teacher. At the institute, she was well known locally for taking in waifs and strays, and even wrote a book on dog welfare. However, in 1914 her life was overtaken by the First World War, and the institute, soon in German-occupied territory, was turned into a Red Cross hospital for the wounded from all sides. Cavell bravely helped more than two hundred fugitive French, Belgian, and British soldiers to escape from behind enemy lines before being discovered and arrested by the Germans in August 1915. Ironically, a postcard of thanks, sent from England by an escaped soldier, was the final piece of incriminating evidence, and she signed a full confession. Cavell was shot by a firing squad at two o'clock in the morning on October 12, 1915, and, almost as soon as the news spread, was acclaimed a martyr. The words she spoke to the English chaplain are famous: "I know now that patriotism is not enough. I must have no hatred and no bitterness toward anyone."

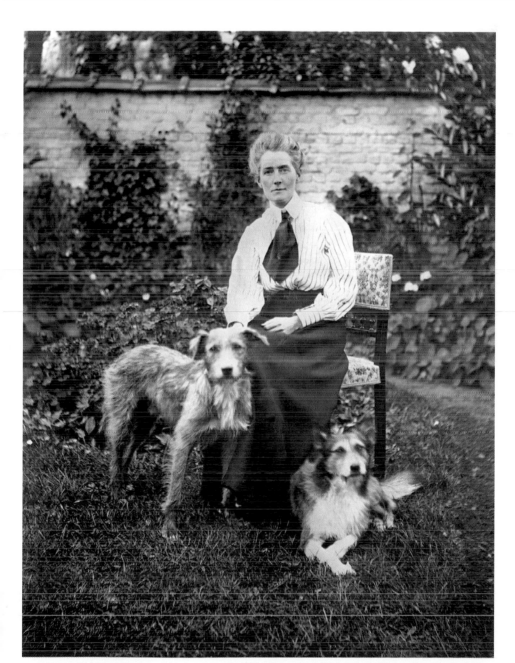

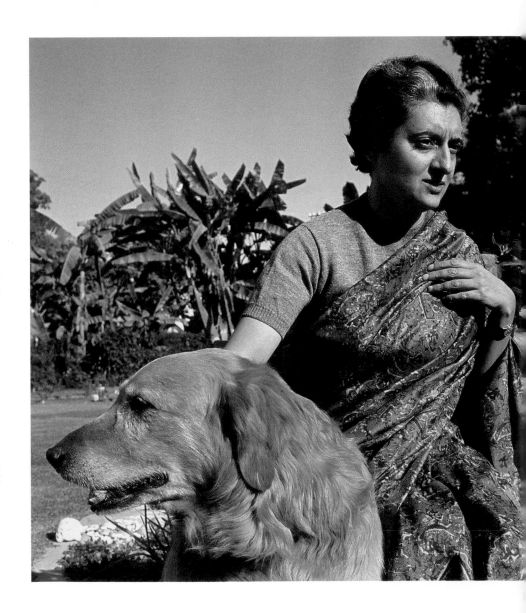

Indira Gandhi and one of her golden retrievers, 1966

This portrait of Indira Gandhi (1917–1984), at her home in New Delhi, dates from the year of her election as prime minister of India; undaunted by the task of leading 480 million people, she said, "The only persons who don't have problems are the dead." The only child of Jawaharlal Nehru, India's first prime minister, the "daughter of the nation" spoke of her affection for golden retrievers as being due to familiarity: Nehru had used a police-trained golden retriever to guard his home day and night. However, Indira Gandhi kept her nine-year-old dog Madhu and two bitches, Putlu and Papee, as companions. When Madhu was younger he had been a great retriever, she told *Life* proudly, adding that, while they weren't official guard dogs, they "don't like to see anyone coming into my room."

Maria Callas with her poodles, **Toy** and **Djedda**, 1959

The legendary Maria Callas (1923–1977) acquired Toy, her first poodle, in 1954, when she had achieved her transformation from fat soprano to thin, elegant diva. The dog would be tucked under her arm when Callas was offstage, every inch the chic woman of fashion. Djedda (in the foreground here) and Pixie, Callas's next two poodles, had an even more special association. They were a gift from her lover, the Greek shipping tycoon Aristotle Onassis, and witnessed her tempestuous relationship with him before he married Jacqueline Kennedy. Djedda was brown and was named after the Saudi Arabian city; Pixie was white. Journalists interviewing Callas were introduced to the dogs and were told their story. In her final years the dogs lived with her in Paris and were dressed in little coats when the singer took them for their walk.

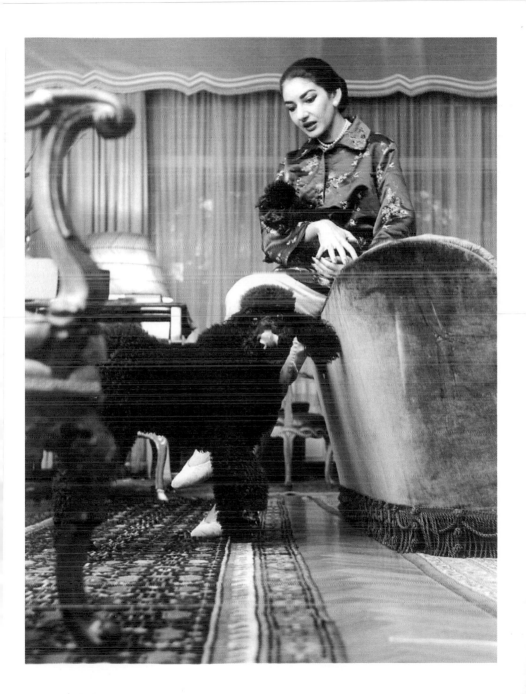

Anna Magnani with her English setter, 1943

The great Italian actress Anna Magnani (1908–1973) poses with one of her dogs shortly before she starred in Roberto Rossellini's *Open City* (1945). The film made her a star and she and Rossellini became lovers—until he left her for Ingrid Bergman. Magnani went on to a distinguished career, working with many important European directors—Fellini, Pasolini, Renoir, and Visconti and won a Best Actress Oscar for Tennessee Williams's *The Rose Tattoo* in 1955. When she was in Rome, she would sneak out of rehearsals or go out at night dressed as a beggar to feed the hundreds of stray cats and dogs in Piazza Argentina. Franco Zeffirelli, who worked with her on *Bellissima* (1951), remembers her great flea-killing technique as the best part of filming. Someone would bring her a stray dog and she would caress it and snap its fleas between her thumbnails. "All the time she would be gossiping and flirting, and every sentence would be punctuated with those snappy little clicks."

Barbara Woodhouse with a Great Dane and a terrier, 1940

Animal trainer, broadcaster, and author Barbara Woodhouse (1910–1988) of course had dogs of her own, including Argus, a German shepherd, but she is best known for her relationships with other people's dogs. Seen here in 1940, the year she divorced her first husband and married her second, Woodhouse would scarcely change her style of dress or, indeed, her grand manner for the rest of her life. She was the forerunner of TV's *Two Fat Ladies*, bossing her way into the nation's heart with her firm belief that "there are no bad dogs, only bad owners." From 1954, when she published *Dog Training My Way*, owners were taught to communicate (and dogs to obey) by using the right tone of voice and clearly enunciated words: her "Walkies!" became a catchphrase when she was given her own television series on obedience training in 1980. Nor could she bear overly sentimental owners with pampered pets: these people, she said firmly, should simply not be allowed to own dogs, and using dogs as fashion accessories was anathema to her. This frankness and the fact that she was always on the side of the animal endeared her to the British. "Many owners expect far too much from their dogs with far too little concentrated effort on their own part," she wrote in *Owners Need Training Too*. "Most of my time is spent teaching the owners . . . to be firm, to be loving and to be gay with their dogs."

Lauren Bacall with **Harvey**, her boxer, 1955

Harvey the boxer was a present to Lauren Bacall (born 1924) on her marriage to Humphrey Bogart in 1945. The dog was named after Harvey, the invisible giant rabbit of the Broadway play and film; "Harvey" was also Bogart's pet name for Bacall. The pup was escorted by Max Wilk, just back from the war, from Chicago to Bogart's home in California. The trains were full of veterans returning home, and there were no tickets to be had—until Warner Bros. arranged a compartment for the pup and his chaperone. It took them two days and a night to get to California. A hungover Bogie arrived at the station, carrying a jug of martinis, to meet them, and was joined there by Bacall, who was looking pale and wan but fell in love instantly with the dog. The Bogarts' home was full of boxer dogs after this, but Harvey was always special: "Harvey was like a person to Bacall," said her son, Stephen. Harvey died of heart trouble, soon after Bogie, in 1957. Sometime later, Max Wilk saw Bacall at a party and reminded her of his arrival with the boxer. "Oh, God! Harvey! He was the best! We loved him madly."

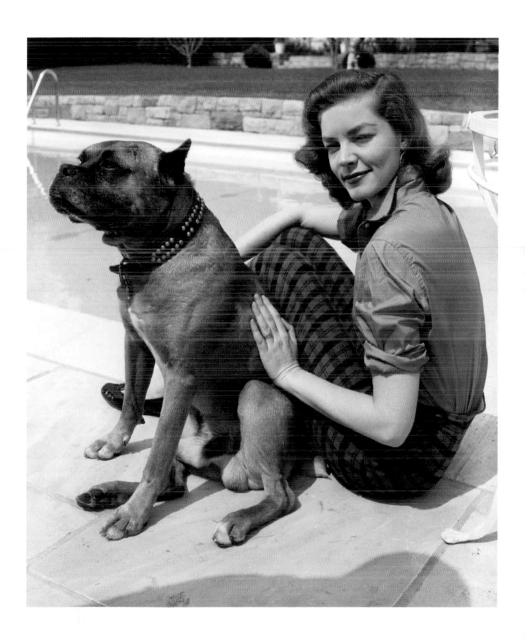

Madonna and the Maltese terrier Jean-Paul, 1994

Chiquita, Madonna's S and M Chihuahua, is far better known than this rather passive Maltese (bearing the name of her friend and designer Jean-Paul Gaultier) being kissed by her in 1994. That was a doggy year for the superstar (born 1958). She acquired first a pit bull terrier named Pepito and then the tiny Chihuahuas Chiquita and her sister Rosita (there was also one Madonna kept in London, named Evita). Chiquita was immortalized, clad in black leather bondage gear, being gently smacked in the "Heart's Desire" video in 1995, and in a memorable shoot for *Icon* magazine dog and owner wore matching leather. Madonna and the dogs were, it seemed, inseparable; even on the Concorde, there was usually a tiny dog clasped to the Material Girl's bosom. But, perhaps unsurprisingly, when Madonna's daughter, Lourdes, arrived in 1996, Chiquita was incapacitated with jealousy and went into therapy with dog psychiatrist Shelby Marlow to overcome her "issues." It worked: Chiquita and Lourdes became absolute best friends, and "dog" was one of the baby's first words. However, in 2000, after Rocco, Madonna's second child, with Guy Ritchie, was born, the dogs simply *had* to go, and they were given a new home with a friend, cult actor Glenn Shadix.

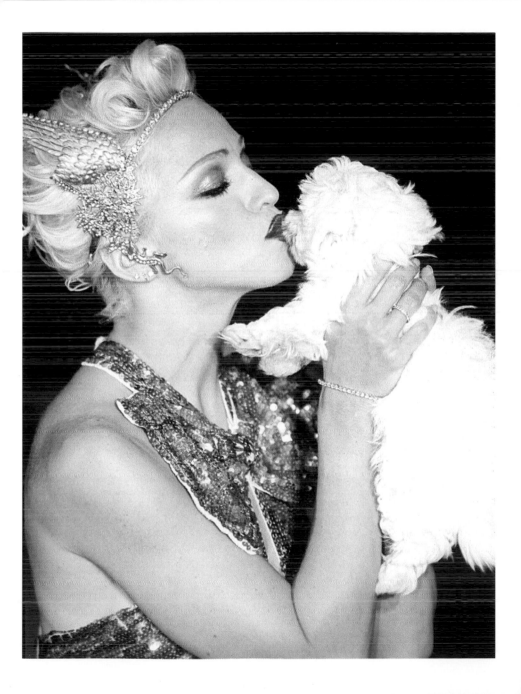

Josephine Baker with her Pekingese, **Baby Girl**, and her Brabançon, **Fifi**, 1928

Nancy Cunard wrote in *Vogue* of the "perfect delight" of Josephine Baker (1906–1975), "most astounding of mulatto dancers, in her necklets, bracelets and flouncing feathered loincloths." It was 1924, and the St. Louis–born American dancer had become the star of the Revue Nègre in Paris, where she was revolutionizing attitudes and was to become one of the highest-paid black stars of her time. Baker pandered to people's preconceptions with a certain irony, driving around Paris in a Voisin motorcar upholstered in brown snakeskin, with a "white esquimaux dog" on whose head was planted the red imprint of her kiss. She was passionate about animals, feeling that she could tell her pets "everything, my joys, my hurts," and she turned her hotel rooms into a menagerie of rabbits, white mice, dogs, cats, birds, and a cheetah named Chiquita. As a child, Baker was hired out as a servant to a sadistic woman, Mrs. Keiser, at whose house she slept every night with an old rescue dog she called Three Legs in his box in the cellar. He, along with a chicken she adopted, was her only friend, and she lived in fear of his being taken away from her. As an independent woman, she was able to indulge her love of animals and bought three dogs in the mid-1920s when she was on tour. The American journalist Robert Mountsier interviewed her in Copenhagen with the trio: a griffon and, shown here, a Peke named Baby Girl and a Brabançon named Fifi. Baker played with them during the interview, which seemed to have delighted Mountsier, who reported in *The New York Sun* that "the winner by any contest for the most popular American would be Josephine Baker."

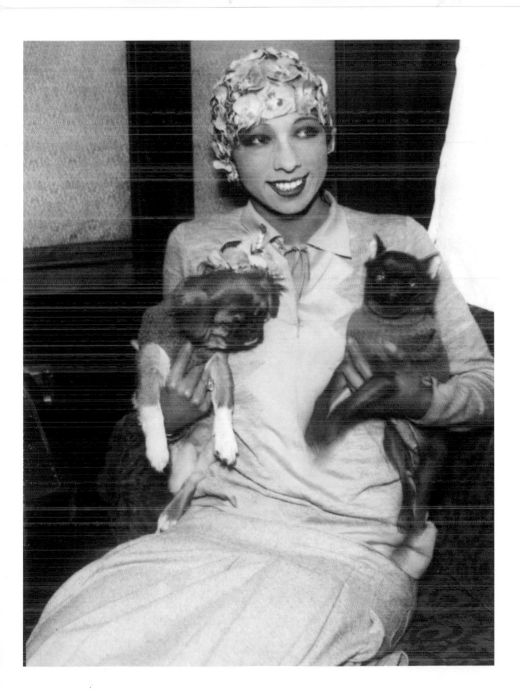

Emmanuelle Béart and her Chihuahua, 1992

This picture of the French actress Emmanuelle Béart (born 1965) and her Chihuahua was taken around the time of her award-winning performance in *Un Coeur en Hiver* (1991), a film that consolidated her reputation following a bewitching appearance in the Provençal peasant drama *Manon des Sources*.

Karen Blixen with her deerhound, **Dusk**, 1919

In old age Karen Blixen (1885–1962) spoke of the "misery of a dogless life," something she had always striven to avoid. The author of *Out of Africa* and *Babette's Feast*, Blixen (whose pen name was Isak Dinesen) grew up in Denmark, alongside her family's German shepherds, and when in 1914 she married her cousin, Baron Bror von Blixen-Finecke, and moved to Kenya to start a coffee farm, she was given a pair of deer-hounds as a wedding present. She called them Dusk and Dawn, and eventually they bred a pack of deerhounds that included Askari, Pania, David, and Dinah. The local people called the breed "Lioness dogs," not because of their appearance, but because she herself was known as Lioness Blixen—a mispronunciation of "Baroness" that suited her and stuck. Several years later she left the dogs for a while in the care of a friend, and Dusk ran off into the bush. Returning, Blixen searched for him for a week before eventually finding him, desperately weak, beside a zebra that had injured him before it died. He died the next day. "My wonderful faithful Dusk. I miss him so much, and if I live to be seventy I believe I will never think of him without weeping," she wrote in a letter. When she returned to Denmark in 1931, she left her two last dogs with friends near Gil-Gil, where they "would get good hunting." There fol-lowed other dogs, including Pasop, her beloved German shepherd. Her last was an "irresistible" little Dandie Dinmont named Pepper—like the Scottish deerhounds, a member of a romantic and chivalrous breed, kept and popularized by one of her own favorite writers, Sir Walter Scott.

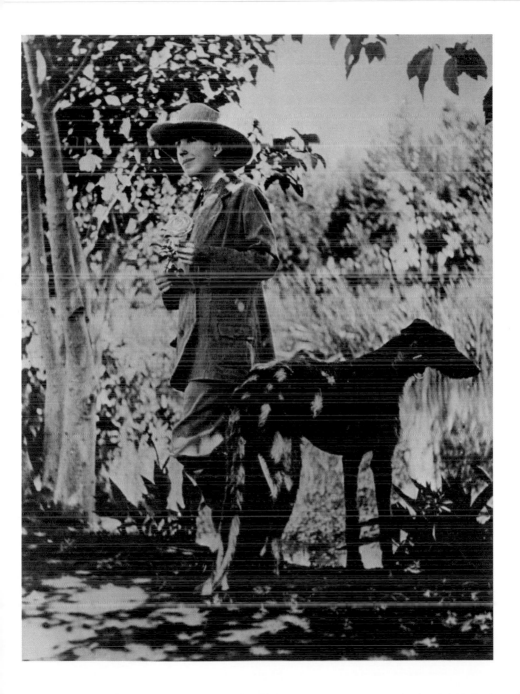

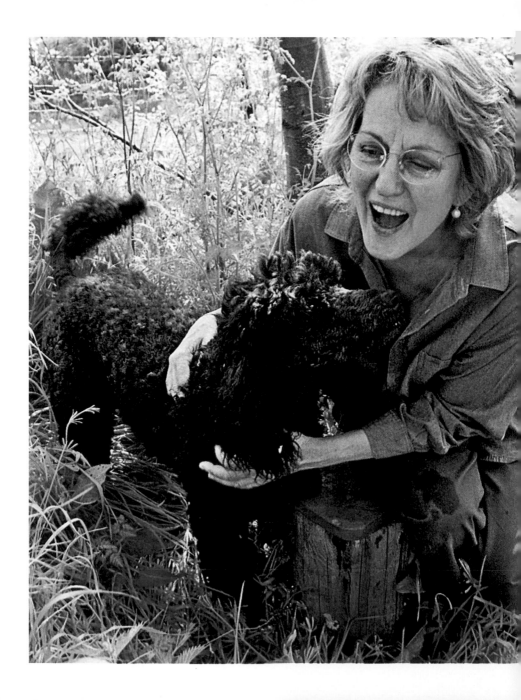

Germaine Greer with her poodle, Molly, 1999

Writer, feminist, polemicist, and gardener, Germaine Greer (born 1939) has been a significant cultural force ever since the publication of *The Female Eunuch* in 1971. She has written since then on the whole gamut of contemporary mores, though alas not enough on dogs, which are a passion, and about which, of course, she has particular and strident views. She raised eyebrows when she wrote that women "can love animals with such tenderness that they would die for them." Greer lives in the Essex countryside with a black standard poodle, Michael, and a retired greyhound named Magpie, who replaced her late beloved black standard poodle, Molly. Greer insisted that Magpie should be black, so Michael would connect her with Molly, but whereas Molly "galloped like a small black pony," she wrote in her "Country Notebook" column in the *Daily Telegraph*, "Magpie is pure spring-heeled hound." With her usual singularity, Greer speaks to her poodles in French, which she believes they understand better than English, although Magpie, she says, will respond only to a whistle.

Clara Bow and **Duke**, her Great Dane, c. 1928

Clara Bow (1905–1965) was the original "It Girl"—as the star of a silent movie based on Elinor Glyn's novel *It* (1927). Here, Bow poses on the beach with Duke, a Great Dane puppy given to her by her boyfriend, actor and singer Harry Richman. Duke was a companion for the pair of chow chows that she would parade for her fans, and he soon became a regular feature in her publicity shots. Gossip writers liked to see in his appearance signs of her on-and-off relationship with Richman, though she famously quipped, "The more I see of men, the more I like dogs." The writer F. Scott Fitzgerald called cupid-lipped Bow "the girl of the year . . . someone to stir every pulse," and she was perhaps America's first sex symbol, receiving, at her peak, 45,000 fan letters a month. Her career was brief, however. She had a thick Brooklyn accent, which she loathed, and she failed to move over to the talkies. Poor reviews, a lack of confidence, and sordid court cases led to her retirement in 1933, when she married the cowboy star Rex Bell.

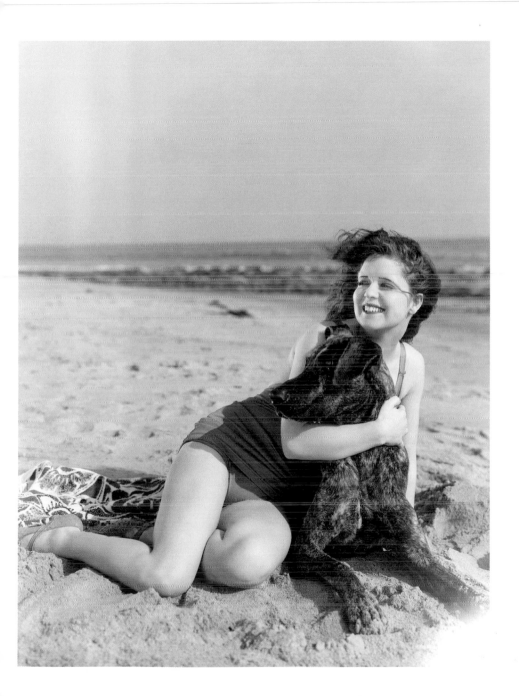

Eleanor Bron with a Great Dane and the Beatles, 1965

Eleanor Bron (born 1938) is pictured here with a Great Dane and the Beatles on the set of the Beatles' second film, *Help!* She played Ahme, a member of an Arab cult that believes in sacrificing the wearer of a ring. Its new owner is Ringo, and the group is pursued across the world as the dastardly villains and other interested parties try to carry out their fiendish plots. In *The Beatles Anthology*, John Lennon is quoted, recalling that "the movie was out of our control. With *A Hard Day's Night*, we had a lot of input and it was semi-realistic. But with *Help!* Dick Lester didn't tell us what it was about. I realise, looking back, how advanced it was. It was a precursor for *Batman*—Pow! Wow! on TV . . . because we were smoking marijuana for breakfast during that period. Nobody could communicate with us, it was all glazed eyes and giggling all the time. In our own world." The Great Dane, then associated in the public imagination with the giant dogs in Hans Christian Andersen's *Tin Soldier* and Sir Arthur Conan Doyle's *Hound of the Baskervilles*, gave just the right touch of canine fantasy to the pop caper.

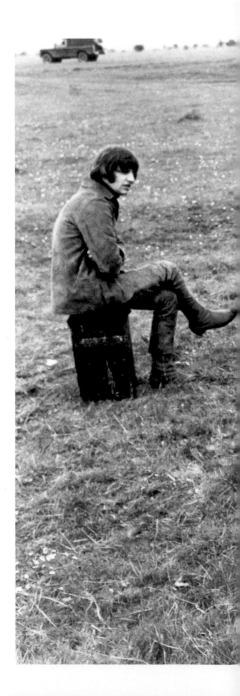

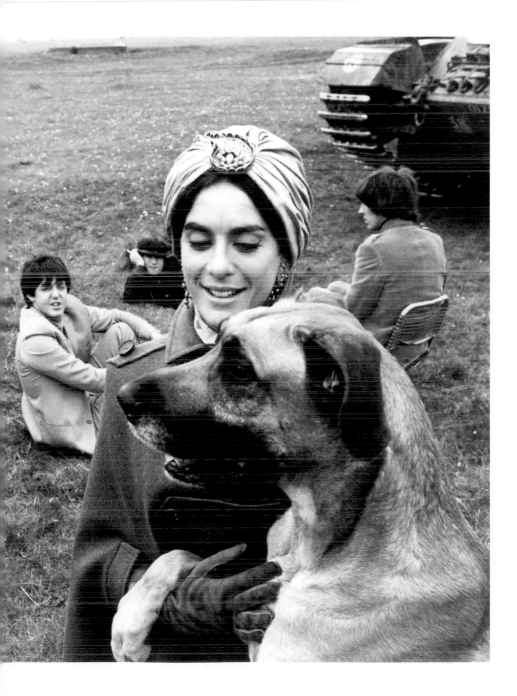

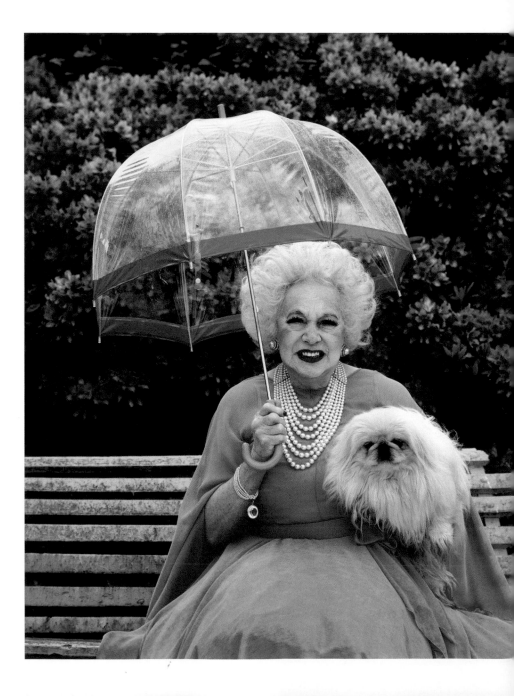

Barbara Cartland with her Pekingese, **Twi-Twi**, 1977

Pekingese were almost a trademark for celebrity romantic novelist Barbara Cartland (1901–2000), and in her later life they were often dyed pink, adding to her overall look, their blond fluffy hair, big dark-ringed eyes, and rotundity matching that of their mistress. Although she kept other dogs (in particular, Labradors), and had a feisty-looking Scottish terrier at the time of her divorce in 1936, the Peke, fashionable during Cartland's youth, suited her age and style—a high-camp version of the Queen Mother with a large dose of baroque fantasy thrown in. "I want to be loved, adored, worshipped, cosseted, and protected," she once announced. No doubt Twi-Twi felt exactly the same: one of Cartland's novels is, after all, called *The Prince and the Pekingese*.

Mrs. Patrick Campbell and **Pinky Panky Poo**, her monkey griffon, 1901

"Dear little beautiful Pinky Panky Poo," wrote Mrs. Patrick Campbell (1865–1940)—the greatest British actress of her generation and the original Eliza Doolittle in George Bernard Shaw's *Pygmalion*—on this photograph of her monkey griffon. Pinky, a German "lady's dog," was presented to the actress by the king of the Belgians. The breed was the height of fashion and, as was only fitting for such a grand little thing, Pinky dined off the best china and slept in the bosom of her mistress. The pair were inseparable, and quarantine laws were regularly broken. When Pinky was old and fragile, Mrs. Campbell tried smuggling her back to England after an American tour, buying a Mexican parakeet to accompany them in the cabin; when Pinky barked, she could tell ship officials that it was the clever bird mimicking a dog. The secret was discovered, but Mrs. Campbell, pleading that her old dog was blind and almost toothless, was let off with a fine of only thirty shillings (£1.50) and was allowed to keep Pinky. Her other dogs included a Japanese Chin and a Pekingese named Moonbeam.

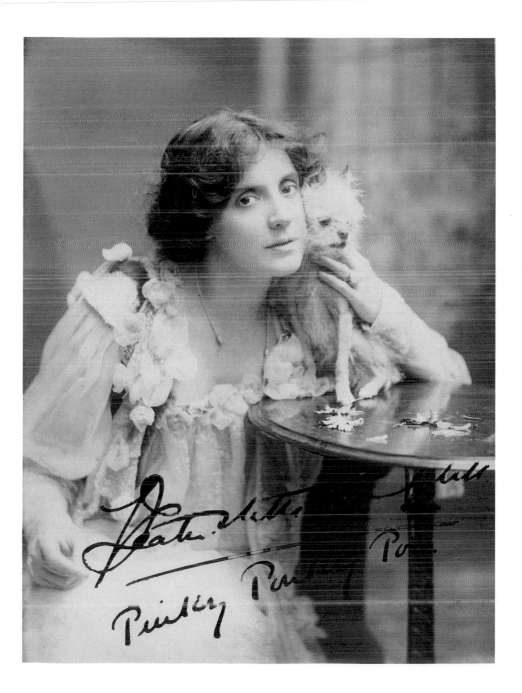

Coco Chanel (on the right) with her aunt Adrienne and her Cavalier King Charles spaniels, 1913

The couturiere Coco Chanel (1883–1971) stands here, striking a pose in front of her first shop, wearing the first of her creations as a designer in her own right. The boutique was in the fashionable French resort of Deauville, where her aunt Adrienne would parade around the town wearing Chanel, advertising the chic and liberating clothes designed by her niece. Socially ambitious, Adrienne kept appropriately aristocratic dogs—Blenheim King Charles spaniels, with the desirable Blenheim spot, the size of a sixpence, on the crown of the head. In 1903, the Kennel Club had decreed that these charming little dogs be called toy spaniels, but such was the outcry over the shelving of the traditional name, with its royal connection, that Edward VII intervened and asked for the historical name to be reinstated—which, of course, it was.

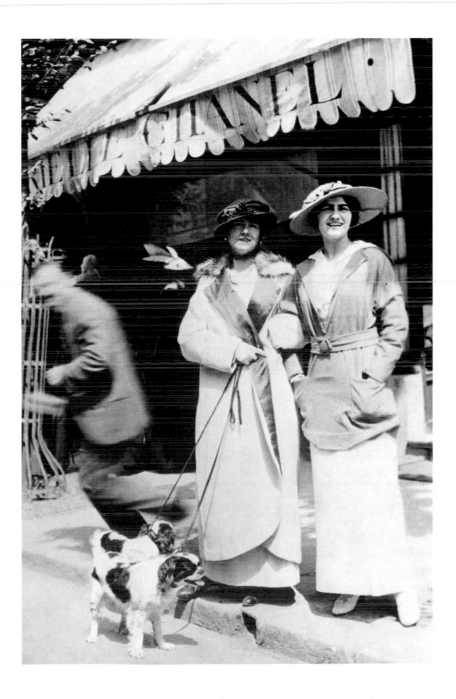

Enid Blyton with her spaniel, **Laddie**, c. 1948

This is the children's author Enid Blyton (1897–1968) with her spaniel, Laddie, who is licking her daughter Imogen's face, with her older daughter, Gillian, on the left. Blyton was one of the best-selling authors of the last century, and possibly the most prolific. She wrote some 120 novels, more than 700 other books, and perhaps as many as 10,000 stories in all, for books and magazines. Her books—simple stories in which good always triumphs—shaped the attitudes of a whole generation of children, not least toward animals. Her father was a great nature lover and instilled this in his daughter. He left when Enid was thirteen, and her mother would not allow her to keep pets, but she made up for this in her adult life, keeping a series of dogs and exotic Siamese and other cats. In about 1927 she got Bobs, the first of several smooth-haired fox terriers. Bobs had his own column in *Teachers' World*, and although he died in the mid-1930s, the column kept going until 1945. The dog pictured here, Laddie, featured as Looney in *The Barney Mysteries* (which began in 1949 with *The Rockingham Mystery*), faithfully reproduced as an irrepressibly playful spaniel, while another Blyton dog, Topsy, appeared with her favorite black cat, Bimbo, in other stories. Scamper, the bouncy spaniel in her *Secret Seven* stories, and Timmy, the clever mixed breed in the *Famous Five* gang, were, however, fictional.

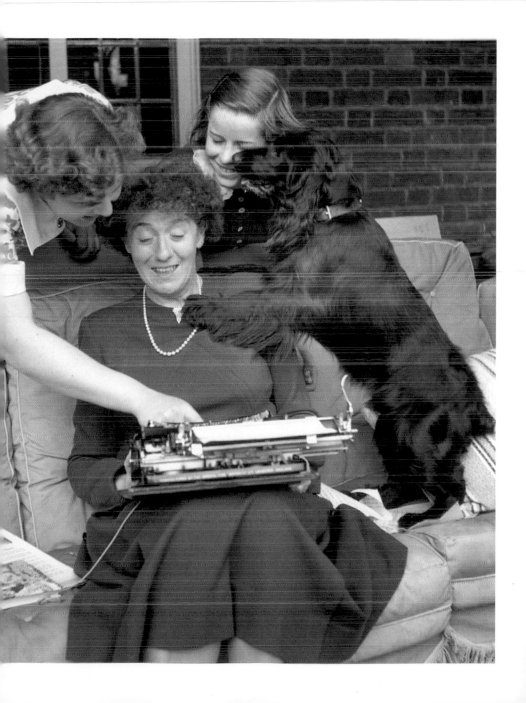

Colette with her French bulldog, Souci, 1935

"Our perfect companions never have fewer than four feet," wrote Colette (1873–1954), one of the great figures of twentieth-century French culture. The novelist adored most animals in general, cats in particular, and French bulldogs above all—she had a long line of bulldogs, from Toby-Chien to Souci, her last dog, pictured here. Bred from Spanish bull baiters and bantam English bulldogs, imported from Nottingham to Normandy by homesick English lacemakers, these bulldogs were by the turn of the century unassailably Gallic and beloved by Parisians. Toby, Colette wrote, was "an adorable creature whose face looked like a frog's that had been sat upon." Toby shared Colette's affections with an angora cat named Kiki-la-doucette. Her novel *Dialogues de Bêtes*, published in 1904, had the two of them in conversation—although in reality it was a metaphor for her marriage to the notorious Willy Gauthier-Villars, publisher of her "Claudine" stories. In 1908, Colette moved out with her cat, a bulldog, and a German shepherd and, liberated from her unhappy marriage, began a lesbian relationship with the Marquise de Morny. Sadly, Colette spent the last fifteen years of her life without an animal, deciding that a pet's inevitable loss through illness or age would be simply too painful to endure.

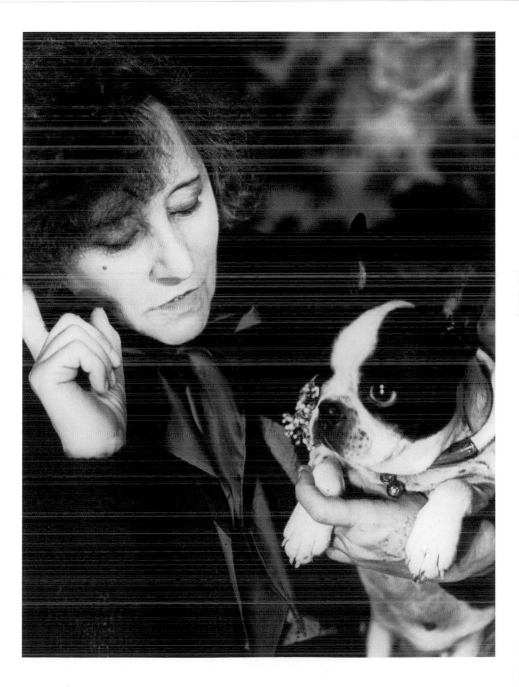

Jilly Cooper with her dogs, **Bessie** and **Hero**, 2003

The writer Jilly Cooper (born 1938) is seen here with her two rescue dogs—Bessie, a Labrador cross, and Hero, a brindled lurcher—at her Gloucestershire home. Dogs have always been part of her life, from the six she has kept as an adult to her involvement with the charity Dogs Trust. "I love their sweetness and good cheer, their welcome when you're a bit depressed," she says. "I love the way they show off. They are never critical and always kind." All hers have been rescues, and she has done much to defend and promote the nonpedigree mixed breed. Animals appear in all her books, good reads like *Riders*, *Rivals,* and *Pandora*, in which Bessie appears as Visitor, a large Labrador who is a brilliant dancer. Cooper lovers will also recall how überhero Rupert Campbell-Black admits to millions of viewers in a television interview that the person he would most like to see in the afterlife is Badger, his deceased black Labrador. Active in animal welfare, Cooper has written often of dogs in her columns, and in her book *Animals in War* (1983), she tells the story of how millions of animals died in active war service in the last century. "The dogs used by the Americans in the Vietnam War weren't allowed back into the U.S., as transport and quarantine was deemed too costly. They were left, chained in their kennels, for the Vietcong." Her sense of outrage has been channeled into campaigning for the recognition of the role of animals in conflict, and in November 2004 the Animals in War Memorial Fund erected a monument at Brook Gate, in London's Hyde Park.

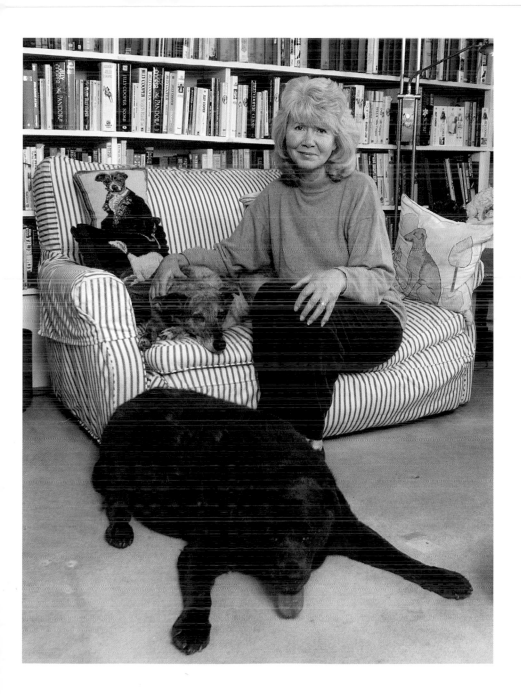

Joan Crawford with three toy poodles, 1959

This is a rare intimate portrait of movie star Joan Crawford (1904–1977), by Eve Arnold, showing her in the white pajamas she always slept in. Crawford was said to be obsessed by cleanliness, washing her hands every ten minutes and wiping doorknobs touched by guests, so it is interesting to see her with toy poodles, sitting on the kitchen table and showing off for the camera. In her early years MGM had furnished her with a black Belgian sheepdog, photographed dragging her on the leash, and dachshunds had followed. In the early 1950s she acquired Clicquot, a white miniature poodle, famously photographed being introduced to Elizabeth Taylor in 1953. Here she has more fashion accessories of the day, and no doubt she liked the fact that these little poodles were bathed and tonsured as a matter of course. Crawford was the widow of Alfred Steele, formerly the chairman of Pepsi-Cola, but was flat broke when Arnold took her classic set of pictures. She had downsized to a smaller apartment and gone back to work, making *The Best of Everything* (1959). In 1962 she starred in *What Ever Happened to Baby Jane?* alongside her loathed rival (and fellow poodle fancier) Bette Davis. When filming ended, Crawford telephoned Arnold in the middle of the night, ecstatic, and said to the photographer, "You would have been so proud of me. I was a lady, not like that c*** Bette Davis!"

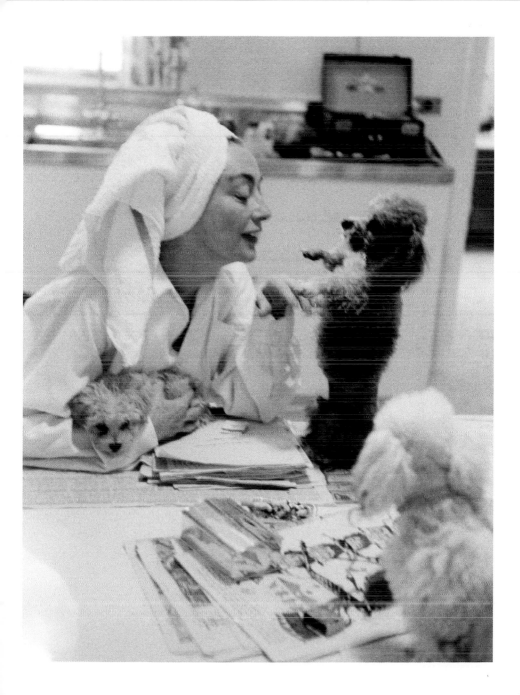

Felicity Huffman and her husband, **William H. Macy**, with their Bernese mountain dog, **Walter Wallingford**, 2000

Felicity Huffman (born 1962) was propelled to A-list Hollywood status—and an Emmy Award for best comedy actress—by her role as Lynette Scavo in ABC's hugely successful series *Desperate Housewives*. But she was already an acclaimed actress, with screen credits including the independent film *Transamerica*, and a series of roles with New York's Atlantic Theater Company, notably as Donnie in David Mamet's *Cryptogram*. It was at the Atlantic that she met her husband, and the theater's co-founder, William H. Macy. The couple live, these days, in Los Angeles with their two children and Bernese mountain dog, Walter Wallingford, who regularly takes his exercise with them at the dog run at Runyon Canyon in the Hollywood Hills. This has become a hot Hollywood locale, where the dog-walking regulars number actors, musicians, and Tinseltown shakers, among them Calista Flockhart and Melissa Etheridge. Macy told journalist Jessica Shaw that the run takes them twenty-five minutes: "It gives me a chance to talk to all the other actors, and it's nice to not be in a car for once. And [Walter] is knackered by the time we get home." Huffman and Macy are clearly devoted to Walter, and Macy even wrote a song about him, which appeared in an issue of *In Style* magazine: "He's got a master's and a Ph.D./He's a roly-poly fatty/He's a cool dog daddy/Looking sharp in coat/He's never garrulous/He's got his own Web site/Picasso did his collar/He's a Mensa scholar/Walter Wallingford/He's got scholarship to MIT/Majoring in algebra/Minor in poop and pee."

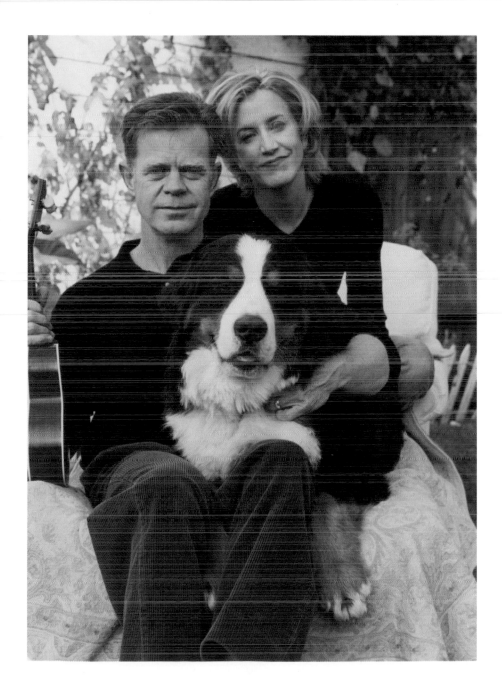

Joan Collins and a pink poodle, 1955

This is one of the many publicity pictures taken of the young Joan Collins (born 1933) as a budding star at Twentieth Century–Fox. She was already a big name in Britain—in her autobiography, *Past Imperfect*, she says she was regarded as Marilyn Monroe, Sophia Loren, and Brigitte Bardot rolled into one—and this was her big chance to make it in Hollywood, where she moved to make *The Girl in the Red Velvet Swing*. At home in Britain, the actress had cultivated a glamorous image, keeping a pet spider monkey. But in Hollywood these little miniature poodles were de rigueur, and dyeing them pink was seen as fun—and particularly apt for an actress dubbed by *Oggi* magazine the "pouting panther." If you couldn't handle the real thing, incidentally, figurines were a popular second. *Vogue* editor Diana Vreeland recalled in *DV,* her autobiography, the pink plaster poodles in Palm Beach: "Quite a beautiful pink, actually, like a du Barry rose. . . . Apparently, they can't keep the poodles in stock—not possibly."

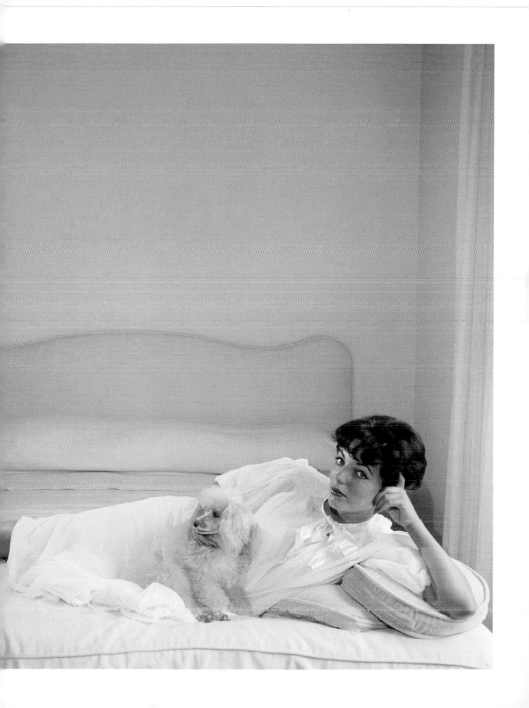

Bette Davis with her two bichons frises, 1932

Bette Davis (1908–1989) was at the start of her career at Warner Bros. at the time of this picture, which splendidly shows off the styling of both the dog-loving actress and her "poodles" (as she referred to them). She had married for the first time that same year, to Harman O. Nelson, and the dogs had been in attendance—washing themselves throughout the ceremony in Yuma, Arizona. Three years later, Davis acquired a little Scottish terrier bitch that she named Tibby. Terriers were all the rage for fashionable ladies in the early 1930s, and Tibby, described as half ham, half dog, played up to her mistress's stardom and was Davis's constant companion and confidante during her twelve years. After President Roosevelt's Fala, Tibby was the most photographed dog in America.

Princess Alexandra with her borzoi, **Alex**, 1897

Princess, later Queen, Alexandra (1844–1925) became a patron of the Ladies' Kennel Association in 1894 and entered with gusto into showing dogs. At this time, the royal family embraced foreign breeds; her husband, Edward, had a Tibetan mastiff and a brace of Rampur hounds, while the princess loved chow chows, skipperkes, and Japanese Chin spaniels. "Billy and Punchy are the favorite boudoir dogs," wrote a biographer in 1902, and described Alexandra going for a walk at Sandringham with ten dogs, all under the total control of their mistress. Here she stands with her favorite borzoi, a gift from Czar Nicholas II in 1895; the breed was unknown in Britain before 1863 but was now living proof of the close family ties between the imperial Russian and British royal families. Alex won more than a hundred awards at dog shows and captured the romance of Russia. People lined up patiently to see this beautiful dog, a celebrity in his own right.

Elizabeth Taylor with her Shih Tzus, **Georgia** and **Elsa**, 1973

As a child actress, Elizabeth Taylor (born 1932) starred in the animal classics *Lassie Come Home* and *National Velvet*, and her pets appeared to be part of MGM's aggressive publicity campaign for the young star. "Elizabeth Taylor Loves Animals and Out-Of-Doors," reported *Life* magazine, listing her pets, and adding that her quiet personality had a hypnotic effect on dogs and horses. In 1946 her own book about her chipmunk, *Nibbles and Me*, was published. Taylor's affection for her animals was very real, and her dogs were a confirmed part of her entourage. In 1968 she and her fifth husband, Richard Burton—the decade's most glamorous couple—set up their London home on board the *Beatriz*, a yacht moored on the Thames, in order that their dogs, including this pair of exotic Shih Tzus, could avoid quarantine. The actress nowadays lives in Los Angeles with her companion Sugar, a Maltese "who understands every word I'm saying to her."

Dolores Del Rio with her English bull terrier, **Faultless of Blighty**, 1936

The Mexican actress and Hollywood star Dolores Del Rio (1905–1983) was returning to the United States after filming *Accused* with Douglas Fairbanks, Jr., when this photograph was taken of her with one of her prizewinning bull terriers, Faultless of Blighty, looking out of a train window at Waterloo Station. Along with Greta Garbo, Del Rio was regarded at the time as Hollywood's most perfect beauty, and had been famously pictured two years previously perched halfway up a stepladder clutching a white English bull terrier pup and wearing a minimal tennis dress. Del Rio was the cousin of silent-movie star Ramon Novarro, and when she arrived in Hollywood in 1925 she became known as the "female Rudolph Valentino." She starred in a number of films, including *Flying Down to Rio* with Fred Astaire. Although she was a member of the Hollywood elite— her second husband was MGM's art director Cedric Gibbons, who designed the Oscar—her affair with Orson Welles and her legendary collection of underwear scandalized a fairly dissipated community. When Welles left her for Rita Hayworth, she returned to Mexico, where she formed the first actors' union and worked with the celebrated filmmaker Emilio Fernandez, winning three Ariels, the Mexican Academy Awards.

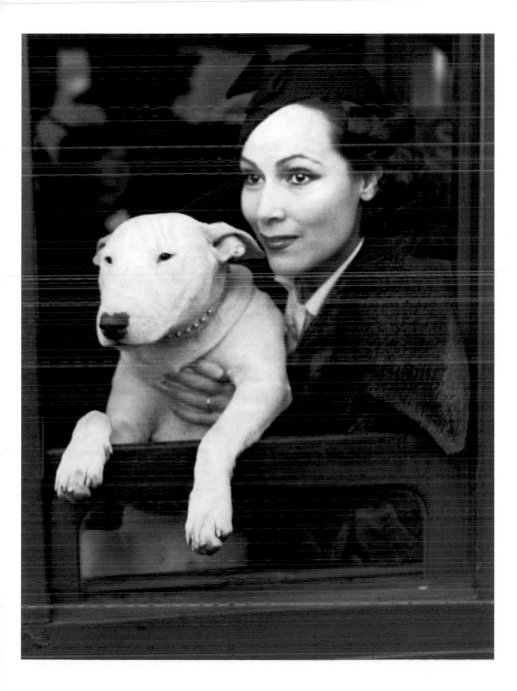

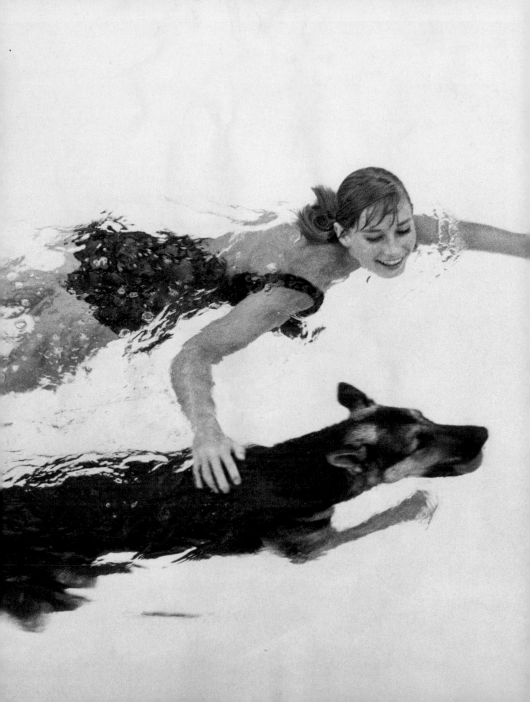

Tania Mallet with a German shepherd, 1961

This shot of model and actress Tania Mallet (born 1941) swimming with a German shepherd appeared in a story titled "How to Be a Raving Beauty," in *Vogue*. Models were just as likely to be photographed with a cheetah in the world's most important fashion magazine, but there is a certain egalitarianism to this lovely shot by Vernier. It was also a very modern image for its day, its action and movement contrasting strongly with the usual dog as fashion accessory—a Yorkshire terrier, carried under one arm.

Ava Gardner with a Pembrokeshire corgi puppy, 1955

This is Ava Gardner (1922–1990) in consciously Spanish mode. She had just moved to Madrid, having left her third husband, Frank Sinatra, for the great Spanish bullfighter Luís Miguel Dominguin. Cardiganshire and Pembrokeshire corgis were her favorite dogs, and she had one of each in Madrid, where the former dictator of Argentina, Juan Perón, was a neighbor. His girlfriend had a pair of "yippy" lapdogs that Gardner once had her two "very aristocratic corgis" chase; ten minutes later she was almost arrested by the Civil Guards. In her last years, which she spent in London, Gardner kept a Pembrokeshire named Morgan, whose favorite treats were raw carrots and walking with her daily in Hyde Park. The late Helmut Newton remembers a photo session with the actress, who kept him waiting for two and a half hours and then got him to photograph Morgan, too. She said that she liked his pictures of the dog and asked for three copies: one for a friend, one for Morgan, and one for Morgan's girlfriend. "I must be a good doggy photographer," Newton remembered, unamused. Morgan was with her when she died, and the dog was then adopted by her old friend Gregory Peck.

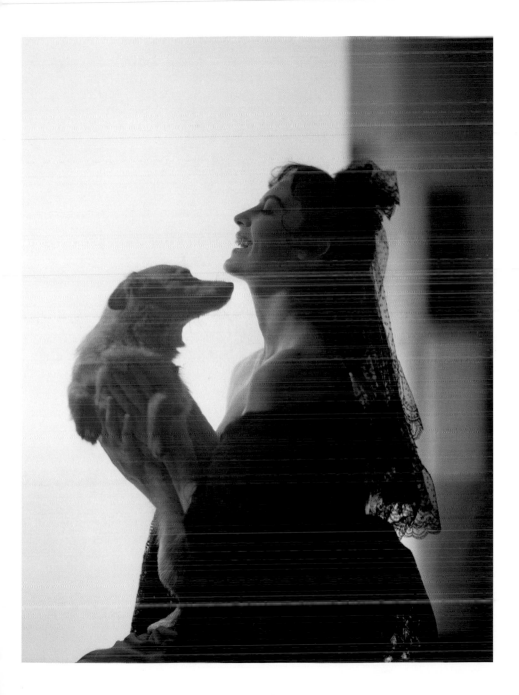

Doris Day and a rescue dog, 1971

Doris Day (born 1924) used to be called "America's sweetheart," as the blond singing star of such 1950s classics as *Calamity Jane* and *Pillow Talk*, and with her theme song, "Que Sera, Sera." Today she is a dedicated campaigner for animal welfare and protection, celebrating in 2003 the ninth Annual Spay Day USA, and announcing that the one millionth dog or cat had been neutered. As a teenager she was injured in a car crash and spent a year on crutches, ending her dream of being a dancer. Her constant companion was her dog Tiny, sensitive to her moods and a constant encouragement to get better. This was the beginning of what she describes as a "lifelong love affair with dogs." She was seen in her early career as a fluffy girl-next-door heroine, starring in *April in Paris* (1952) with seven poodles, all dyed different colors. In 1960 she was the cover girl for *Look* magazine—again, along with a multicolored pack of poodles. But this picture was taken in 1971, the year she cofounded Actors and Others for Animals, having retired from the movies. In 1977 she founded her own rescue center in Carmel, California, and in 1987 she established the Doris Day Animal Foundation, "dedicated to educating and empowering people to act on behalf of animals."

Jean Harlow holding her Pomeranian, **Oscar**, 1935

The "blond bombshell" Jean Harlow (1911–1937) liked to quote the aphorism "When you lie down with dogs, you get up with fleas," but like so many Hollywood actresses of her era she was a doting collector of pet animals. Not only was there the diminutive Oscar, but also Bleak the brindle Great Dane, Tiger the elkhound, and various cats, goldfish, and ducks. Pomeranians, which weigh around five pounds, were popular in the 1930s; devoted to their owners, the breed had been painted by Gainsborough, had been featured by Beatrix Potter, and had appeared in the pages of *Vogue*. So Oscar was the perfect house dog for the star of *Dinner at Eight*. He must also have been a comfort to Harlow, who was ever unlucky in love: she married three times in her short life, and her second husband committed suicide. At the time of her death, from a kidney condition, she was engaged to the actor William Powell (who costarred with Asta, the wirehaired fox terrier, in *The Thin Man*).

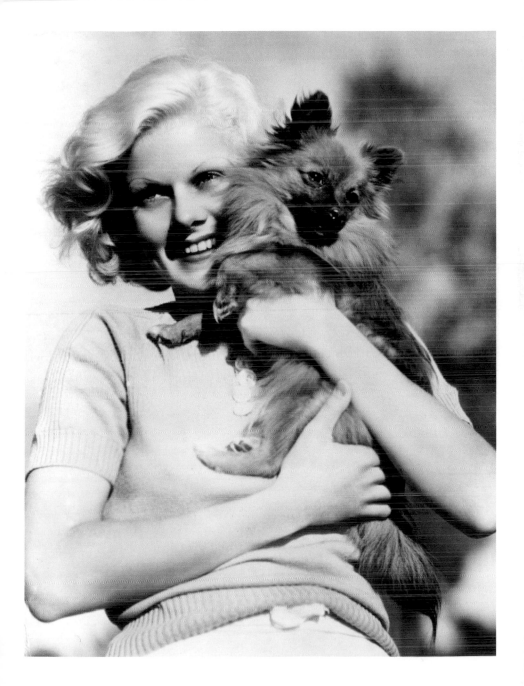

Debbie Harry with her Japanese Chin spaniel, **Ki-Suki**, 2002

Debbie Harry (born 1945) was the pinup of punk. She might have hung out in New York with Patti Smith and Nancy Spungeon, and trashed hotel rooms with the best of them, but fronting her band Blondie, she was the sex goddess of the times, its miniskirted Garbo—no mistaking it, even if you missed the group's ads with their catchy slogan, "Wouldn't you like to rip her to shreds?" Blondie fell apart in 1983, when Harry's partner, Chris Stein, suffered a serious illness. Harry nursed him, made a late '80s comeback, then went quietish until Blondie was revived in 1998. Now sixty, she lives in New York City, in Chelsea, with Chi-Chen, a pug, and Ki-Suki, the Japanese Chin, and wanders the city largely unrecognized—except, as she says, by fellow dog walkers, though "most of the time, we know each other's dogs' names but not our own."

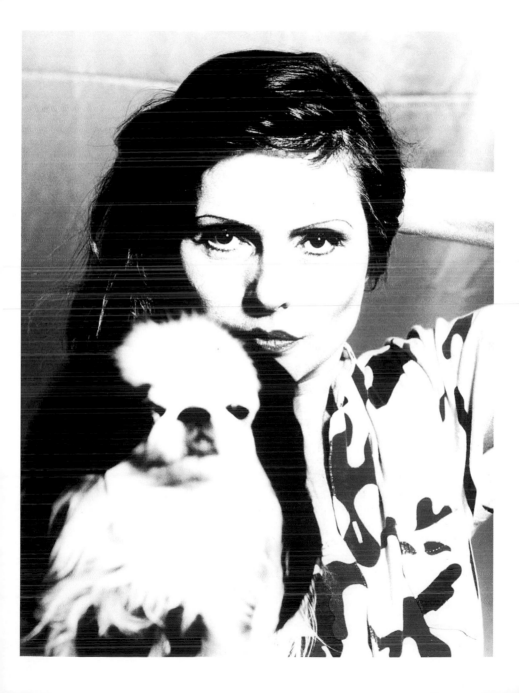

Olivia de Havilland with a borzoi, c. 1937

John Springer took this publicity shot of Olivia de Havilland (born 1916) with a borzoi not long before she began filming *Gone with the Wind*. The actress starred in eight films with Errol Flynn in the 1930s, playing beautiful, gentle, and generally well-behaved heroines in all of them, and the romantic and aristocratic borzoi was chosen to complement the "de Havilland look." In reality, the actress kept bulldogs—and preferred feisty, unsentimental roles, which she eventually won, after fighting a landmark court battle with Warner Bros. to free herself from her contract.

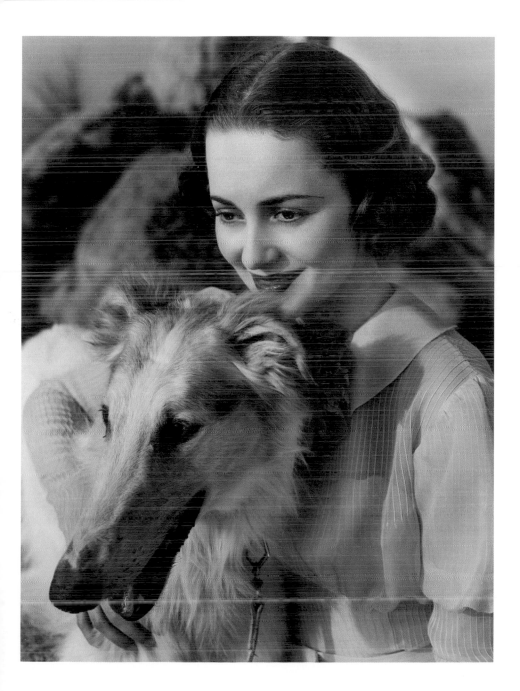

Audrey Hepburn with a poodle, "David," 1954

This glamorous Hollywood still shows Audrey Hepburn (1929–1993) with the gray miniature poodle who starred with her in *Sabrina* (1954), the romantic comedy directed by Billy Wilder. Hepburn plays Sabrina, the deliciously pretty, style-conscious daughter of a chauffeur, and she names her poodle David after the man she has a crush on. The dog is a silent companion, sitting on the actress's lap, trotting beside her, and finally disappearing without ceremony. In real life, Hepburn was, as Billy Wilder's wife Audrey explained to her biographer Barry Paris, "ga-ga over all the dogs she had . . . yippy, yappy, jumpy ones. One day she brought Mr. Famous, her Yorkshire terrier, to see my little female Fifty. . . . He came into our little apartment, took one look at Fifty, and peed on every single chair. I put him out in our backyard. . . . He pushed open that gate. I looked out and he was taking Fifty up and down Wilshire Boulevard, smelling all the bushes."

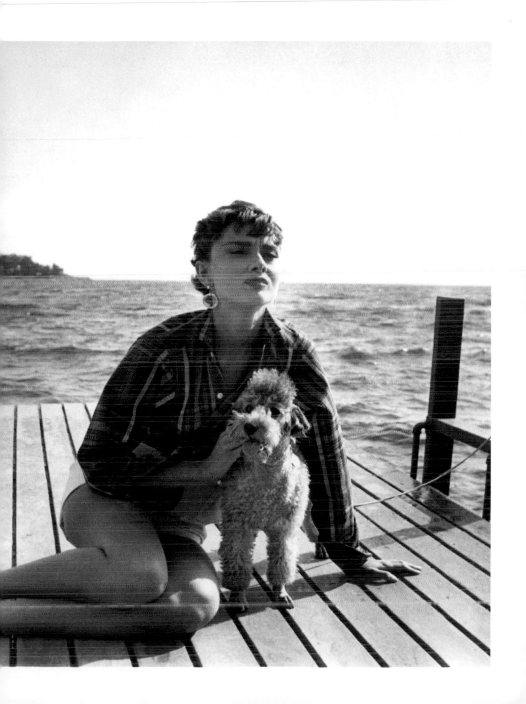

Lady Aberdeen with her Skye terriers, 1910

Lady Aberdeen (1857–1939) is distantly remembered as a social reformer and philanthropist. In Canada, where her husband was governor-general in the 1890s, she set herself against the medical establishment to found a nursing order to serve Canadians in rural and remote areas, and was the first president of the National Council of Women of Canada. However, owners of Skye terriers know her name for her work as a pioneer breeder of drop-eared Skyes, five of which can be seen here; on the far right is the prick-eared variety, which eventually won the popularity stakes. Skyes are one of Britain's oldest known breeds and had been popularized in the 1840s by Queen Victoria. Such was their desirability that the dowager empress of China kept one among her Pekingese in 1903. Despite these fashionable connections, Skyes were originally tough dogs, belonging to Scottish Highlanders and, "by reason of the length of heare which makes showe neither of face nor body," known as hunters of fox and otter. As they became fashionable, their coats became longer and silkier, needing a great deal of combing, and they became regarded as ladies' dogs.

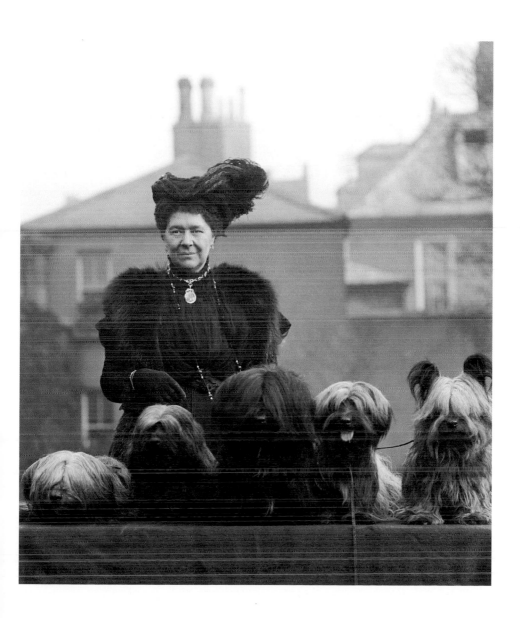

Edie Falco with **Marly**, her Labrador–German shepherd cross, 2000

Character actress Edie Falco (born 1963) became a household name through *The Sopranos*, in which she has been playing Carmela, Tony's long-suffering but tough wife, since its inception in 1999. Tony and Carmela don't have a dog in the series, but if they did you can bet Falco would know how to handle it—and would probably put forward her own Labrador–German shepherd cross, Marly. She adopted Marly from a rescue pound in 1999, and the two go everywhere together, even driving down from New York to Florida for the shooting of John Sayles's *Sunshine State* (2002), in which, strangely enough, Falco played a character named Marly. Perhaps even more strange was an incident in 2003, when Falco was out walking a friend's dog, Gracie, in New York, and Gracie tumbled into the Hudson River. Falco enlisted a passerby to call 911 and stayed with Gracie, who had to tread water for twenty minutes before being pulled to safety by two emergency workers. "Dog won't swim with the fishes," noted one of the New York gossip columns.

Jayne Mansfield with Powderpuff the Pekingese and her puppy, 1958

"The quality of making everyone stop in their tracks is what I work at,"
said Jayne Mansfield (1933–1967), and there was probably no actress
who did it more easily, with her awe-inspiring vital statistics: 46D-18-
36. Yet she was no dumb blonde, despite appearances—which were
enhanced by a body-builder husband, Mickey Hargitay, and these two
Pekes. She spoke five languages, played the violin, and was rumored to
have an IQ of 163. When this shot was taken, Mansfield was living in
a pink palace on Sunset Boulevard with an elephant, monkeys, don-
keys, cats, and ocelots, as well as nine dogs, who were housed in pink
kennels and had, as she put it, "everything a canine heart could
desire. . . . I often wish every child in the world could have the love,
care, and the food that our dogs take for granted." Like so many stars,
she acquired her pets at random and compulsively: on a trip to Britain
she noticed a "magnificent" bulldog, and returned to Los Angeles with
one of his puppies. She had owned some thirty dogs by the time she
died, in a car crash, in 1967. Mansfield's lawyer, her driver, and two of
her Chihuahuas died with her; her children and two other
Chihuahuas survived.

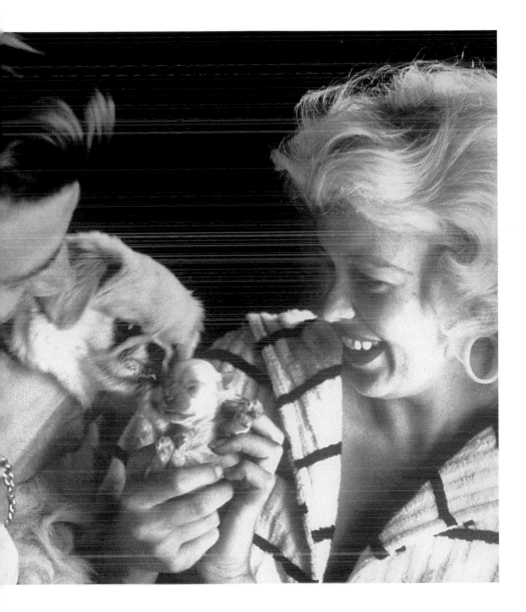

Grace Kelly and a Weimaraner, 1955

The Weimaraner that Grace Kelly (1929–1982) is petting here probably belonged to her family friends the Greenfields. But at the time of the photo, Kelly was a confirmed dog lover in her own right, doting upon Oliver, a black miniature poodle given to her as a pup by Cary Grant and his wife when Kelly and Grant were filming *To Catch a Thief* in 1954. Oliver was endlessly playful and had a penchant for Kelly's trademark white gloves. In Hollywood, Kelly had discreet affairs with a string of married men, among them Clark Gable, Bing Crosby, and William Holden, before becoming engaged in 1955 to Prince Rainier of Monaco. She sailed off for the wedding with family and friends in style, and found, waiting for her in her stateroom, Oliver and a Weimaraner puppy—the gift of the Greenfields. There was another gift, too, from the Hitchcocks: a chain leash decorated with white carnations and satin bows, with a card from their dog Philip that read, "You'll love Monte Carlo. Happy Barking." The Weimaraner was a temperamental dog and completely unhousebroken, so the princess-to-be had her work cut out for her. Every morning she would walk the dogs on deck, and when the ship docked in Cannes she held Oliver in her arms as she greeted her bridegroom—it was all Rainier could do to give her hand a squeeze for the cameras. They were married on April 18, and for a week Oliver was the most famous dog in the world. He was a comfort to her in her first, rather lonely, year of marriage, too, always sleeping at the end of her bed. And although the Weimaraner soon became part of a larger family of pugs, poodles, and Rainier's collection of wild animals, Oliver never left her side.

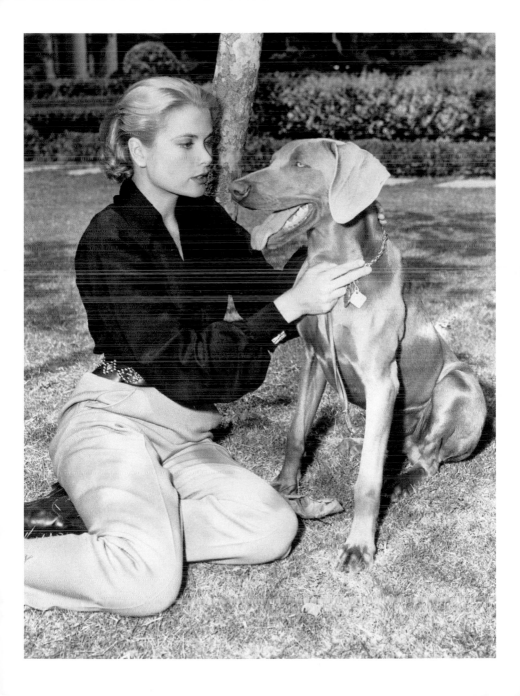

Charlize Theron with **Denver** the cocker spaniel, 1996

The Oscar-winning South African actress Charlize Theron (born 1975) is well known for her dogs and her stance on animal welfare. She shares her home in the Hollywood Hills with four rescues: two cocker spaniels, Denver (seen here) and Delilah; Orson, a Great Dane–Dalmatian–mixed breed; and Tucker, a Rhodesian ridgeback cross. Orson attached himself to Theron when she was filming in Naples, and Tucker was given to her by a friend. "I will go so far as to say that I don't think I could be friends or even acquaintances with somebody who admitted to me, 'I hate animals,'" she told *Interview* magazine in 1999. Denver and pretty black Delilah always accompany Theron in her trailer whenever she is filming, and Denver even had a cameo role in Robert Redford's *The Legend of Bagger Vance* (2000): he had to react to the sound of a gunshot by getting up and standing behind his mistress's legs, and did it perfectly. The actress has campaigned against rape and for AIDS awareness, as well as against puppy farms and pet shops, and supports several rescue centers.

Billie Holiday and **Mister** the boxer, c. 1945

American jazz legend Billie Holiday (1915–1959) had a number of dogs: there was Moochie, a wirehaired terrier; Rajah Ravoy, a mongrel she gave to her mother; and a standard poodle, whom, when he died, she had cremated in her mink coat. But Mister was the singer's best-known companion. "She didn't went anywhere without him," band member Big Stump told her biographer Donald Clarke. "He was the best hangout dog on earth. . . . He would sit backstage near where he could hear Lady's voice. As long as he heard her voice, he's happy. He was a comfortable boxer, gentle boxer, he didn't believe in playing around, all he believe in was Lady . . . not a thing with the paws." It was said that Holiday shared everything, including heroin, with Mister. Whether or not that was true, the two were parted only during her jail sentence for possession of the drug in 1948. The singer later acquired a Chihuahua named Chiquita and, through Ava Gardner, another named Pepe. Lena Horne recalled: "Billie was just too sensitive to survive. The thing I remember talking to her about most were her dogs; her animals were really her only trusted friends."

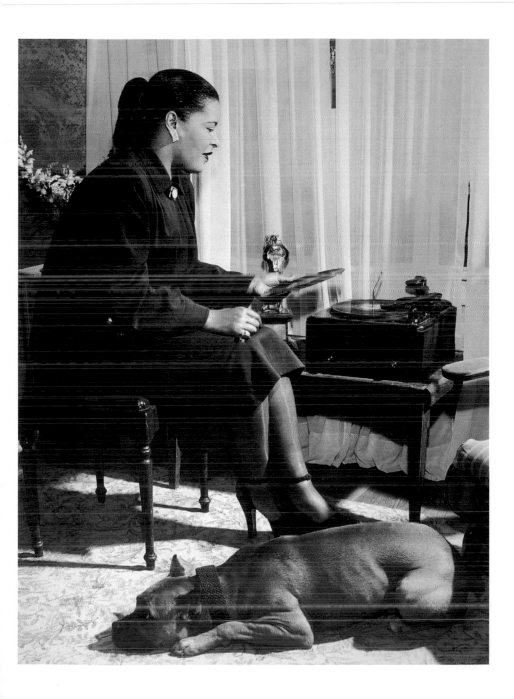

Tama Janowitz and **Nike**, her Chinese crested, 2002

Tama Janowitz (born 1957), author of the best seller *Slaves of New York*, got Nike, her Chinese crested, after Lulu, her Yorkshire terrier, died. She and her remaining Yorkie, Beep-Beep, were depressed about the loss, and after seeing an advertisement for Chinese crested puppies, Janowitz (with Beep-Beep) went to meet them. "They looked like characters out of Dr. Seuss or science fiction, with a demented tuft of hair." Nike was, the breeder promised, "95 percent likely to develop show dog qualities, but turned out to be the 5 percent." Nonetheless, Janowitz was entranced, and the dogs share her home with her husband, daughter, and four pet ferrets (who apparently like Nike—though Nike does not reciprocate). The writer believes that many New Yorkers "need dogs because the people are nasty and are only friends with you when you can do something for them. Dogs love you and accept you, no matter what." She herself had her first dog of her own, Fury, a silvery-gray poodle, when she was eight. Lulu was her first dog as an adult, and is commemorated in "My Dog Lulu": "She had all the bad attributes of human beings: she was sluttish, cowardly, greedy, jealous—which was why I loved her all the more. After all, unlike a person she couldn't help herself; qualities that I would have despised in a person seemed rather charming and amusing in her. There is no spite in dogs." Dogs also appear in Janowitz's fiction: Andrew, the Dalmatian, appears in *Slaves of New York*; in *The Male Cross-Dresser Support Group* there is an affenpinscher; and the eponymous heroine of her latest novel, *Peyton Amberg*, rescues Chihuahuas.

Helen Keller with an unknown German shepherd, 1950s

"I have many dog friends," wrote Helen Keller (1880–1968), the inspirational American writer and disability activist: "huge mastiffs, soft-eyed spaniels, woodwise setters and honest, homely bull terriers." Keller became deaf and blind at nineteen months and was famously taught to communicate by her tutor, Anne Sullivan, who wrote on her hand. And dogs really were part of Keller's life, providing rich rewards for her two undamaged senses, touch and smell. Sullivan wrote that little Helen always knew when her father's setter, Belle, was in the room because she could smell the dog, and "she put her arms round her neck and squeezed her." When Helen started to manipulate Belle's claws to trace the letters "d-o-l-l" on her hand, the family realized she was trying to teach the dog to spell. In adult life, Keller kept a whole string of dogs—as pets rather than guide dogs. There were Great Danes (Sieglinde and Helga), a Scottie (Darkie), a French bulldog (Ben Sith), Shetland collies (Dileas and Wendy), and a Lakeland terrier ("fat Maida"), and Keller was the first to import an Akita into the United States from Japan, in 1938, unwittingly calling him Kamikaze (meaning "divine wind"). "My dog friends seem to understand my limitations," she wrote, "and always keep close beside me when I am alone. I love their affectionate ways and the eloquent wag of their tails."

Jodie Kidd with **Inca**, her Jack Russell terrier, 2004

Inca the Jack Russell is just one of Jodie Kidd's (born 1978) five dogs, but she is the model of the group, having graced the cover of *Dogs Quarterly* (*DQ*) magazine, and even having appeared with her mistress on the catwalk of the designer Julien McDonald in 2003. "Julien fell in love with her. He made her a matching diamanté and rhinestone outfit and she went down the McDonald catwalk with me. She certainly is a poseur," Kidd told *DQ*, which recorded that, when in town, six-year-old Inca wears Burberry, Pringle, and Barbour. At home, however, Inca loves ratting, chasing squirrels, and hunting for rabbits—all the things a well-adjusted Jack Russell enjoys. So, although she might appear the fashionable dog, she doesn't always behave like one. Supermodel Kidd—great-granddaughter of the British press baron Lord Beaverbrook, Evelyn Waugh's "Lord Copper"—began her career at sixteen, and as a teenager was criticized by none less than Bill Clinton, who singled her out as exemplifying the "heroin chic" model aesthetic. Ironically, she seems these days to be the picture of ruddy health, living in the country with her eight horses and her dogs—a sheepdog, the terriers Slinky and Inca, the Labrador Merlin, and Winston the retriever.

Peggy Guggenheim with her pack of Lhasa apsos, 1956

Peggy Guggenheim (1898–1979), the patron and collector of twentieth-century art, is shown here on the roof of her Venice palazzo, wearing her famous Edward Melcarth sunglasses. Guggenheim always kept dogs, from Lola the ferocious sheepdog to Robin the Sealyham. But it was her second husband, the surrealist painter Max Ernst, who set her on the trail of white Lhasa apso terriers, acquiring one that they named Kachina. Guggenheim said that the dog "had done wonders for his meanness" and looked just like him, and allowed him to keep Kachina after their divorce. Ernst later gave Guggenheim two of Kachina's puppies; the breed was still rare in New York at the time. Lhasas were to become "her dogs," and when she traveled to India in 1954, she made a point of going to meet Tenzing Norgay, the sherpa who had climbed Mount Everest with Sir Edmund Hillary, in order to buy a Lhasa. Norgay kept six Lhasas and walked them daily in the Himalayas. Guggenheim failed in this, but eventually she found a suitable mate for her own two. In all, Guggenheim bred some fifty-seven Lhasas and always had several in tow; they invariably posed with her in photographs. Unsurprisingly, she is buried next to her dogs.

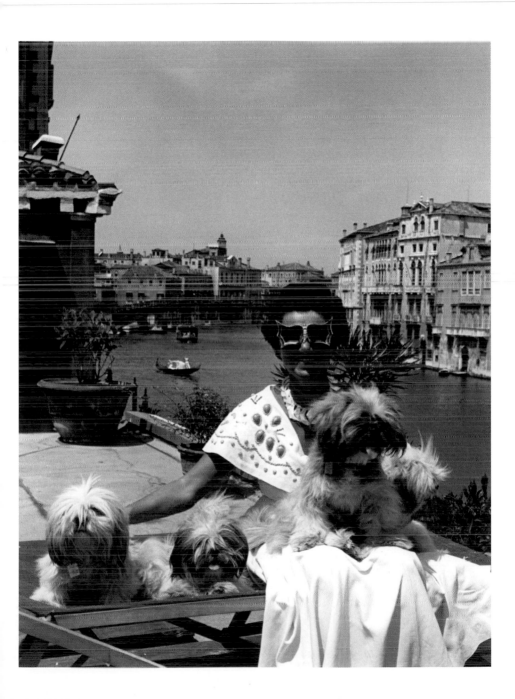

Sam Taylor-Wood and **Sid**, her Staffordshire bull terrier, 2004

The British artist Sam Taylor-Wood (born 1967) has made her own celebrity part of the nature of her work, which is mainly large-scale video and photography. She talks openly of dealing with and surviving cancer, and a recent work was *Crying Men*—portraits of A-list actors such as Ed Harris and Tim Roth weeping real tears, showing vulnerability. That makes her choice of dog interesting. The Staffordshire, culturally the dog of the urban working-class British male, is bred to show his pugnacious side to other dogs, though Staffordshires are often softies at heart. But Taylor-Wood spent her early years with six dogs and eight cats in south London, so she most probably has a relaxed attitude toward animals, useful in keeping a Staffordshire. She has on occasion included dogs in her work, notably in *Soliloquy II* (1998), where a bare-chested young man is surrounded by a lolling group of urban hounds, subverting the classic eighteenth-century British portrait genre of landowner with dog. And she has photographed Sid himself, wrapped in tinsel, for *Vogue*.

Evalyn Walsh MacLean and her standard poodle, **Sarto**, 1910

The American socialite Evalyn Walsh MacLean (1886–1947) was known as the "richest woman in the world," and did much to live up to that billing. In a life of conspicuously conspicuous consumption, her source of greatest happiness was jewelry, and in 1911 she bought from Cartier a legendary 44-carat blue diamond called the Hope Diamond. Once owned by Marie-Antoinette, it had a history of bad luck, but MacLean wore it constantly, and dared the curse to do its worst. She had a similarly unparsimonious attitude toward dogs, dressing Sarto, her standard poodle, in clothes by her own couturiere, Lucile, and employing a dog coiffeur to shampoo and style his hair each week, at $5 a time—a tidy sum in 1912, when the standard poodle was making its entry into the lives of the rich and famous. Later, when she had promised her daughter a poodle but was unable to find one she liked, she bought a prize Saint Bernard—America's champion of champions that year for $5,000. For once, wrote Lucius Beebe, MacLean hadn't been had: "No amount anyone can pay for a Saint Bernard is too much, and she was wise enough to know it."

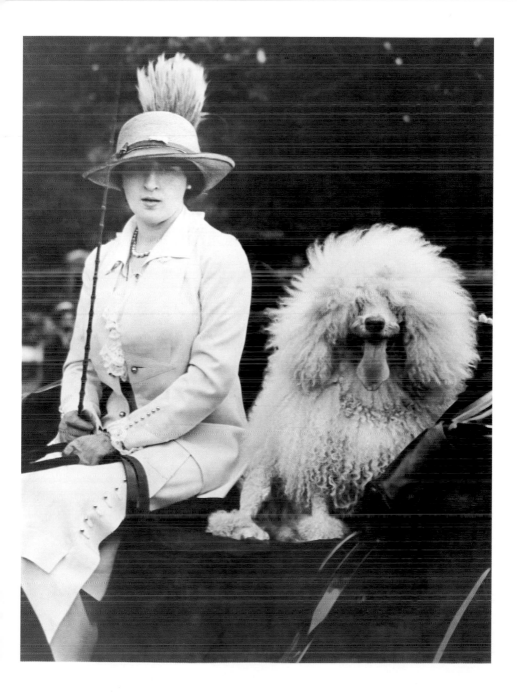

Lady Victoria and **Lady Isabella Hervey** with their dogs, **Cleo** the Maltese, **Zulu** the Norwich terrier, and the family boxers **Gigi** and **Humphrey**, 2003

"They have the most amazing legs. This shot was all legs and leashes," recalls the photographer Jillian Edelstein, who took this Polaroid of the socialite sisters Lady Victoria (born 1976) and Lady Isabella (born 1982) Hervey during a shoot to launch the Dogs Trust charity (formerly the National Canine Defence League). The aristocratic Herveys—models and "it" girls (columnist Victoria has been dubbed a "foot-and-mouth-in-it" girl)—are often compared to the publicity-hungry American heiresses Nicky and Paris Hilton (the latter of whom has a fashionable teacup Chihuahua named Tinkerbell). In this picture the Hervey sisters flank the family boxers, and Lady Victoria is carrying Zulu, her Norwich terrier, while Lady Isabella holds Cleo, her feisty Maltese. Lady Isabella helps the Dogs Trust by making appearances, in 2004 gracing the catwalk with Cleo and other smart dogs at the Harrods "Pet-à-Porter" canine fashion show.

Mistinguett and two of her performing greyhounds, 1925

Mistinguett, born Jeanne Bourgeois (1875–1956), was a legendary Paris showgirl, singer, lover, and star. "You have been the beauty, the spirit, the magic, the symbol of the city of women," pronounced former lover Maurice Chevalier in homage. Dogs were always a part of her life, onstage, where she appeared with these greyhounds, and off, where she kept Great Danes, toy dogs, and a sheepdog named Freddie, whom she had seen sunning himself in an open doorway one day and taken a fancy to. "I asked his owner if he would sell him to me. The man refused . . . but I was welcome to hire him for the evenings. So Freddie spent his nights at the Casino." Mistinguett had many affairs—her lovers were said to have included the kings of both Spain and Belgium—but dogs, and animals in general, were her great constants. "I have said it before and I repeat, that I prefer them to most human beings."

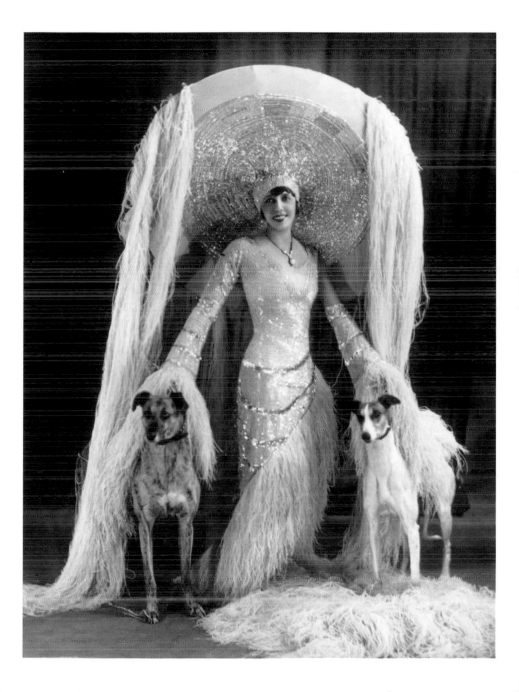

Virginia Woolf with **Leonard Woolf** and **Sally,** their cocker spaniel, 1939

Virginia Woolf (1882–1941) didn't enjoy this photo session with Gisele Freund, finding it an invasion of her privacy, which perhaps explains why she and her husband, Leonard, seem so focused on Sally, their second cocker spaniel. Sally replaced their much-loved golden cocker spaniel, Pinker, who had been a present to Virginia from Vita Sackville-West, with whom she was having an affair. Pinker featured large in Virginia Woolf's letters and diaries, and inspired *Flush,* her story of Elizabeth Barrett Browning's spaniel. The Woolf and Sackville-West dogs allowed for private jokes about sex and disobedience between their owners, suggests biographer Hermione Lee. "How can I face my husband, not that I have been seduced, but that Grizzle [the Woolfs' other dog] has?" recorded Virginia in a diary note. Touchingly, paw prints covered many pages of Woolf's manuscripts.

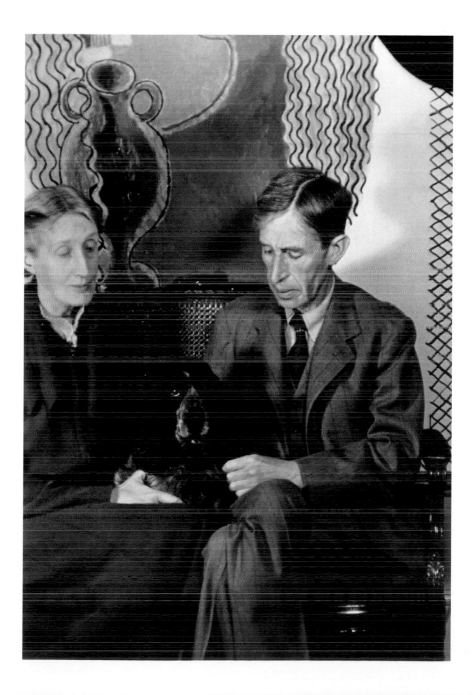

Queen Elizabeth II with her corgi, **Susan**, 1952

For her eighteenth birthday Princess Elizabeth (born 1926) was given Susan, her very own Pembrokeshire corgi, by her parents. Her father, George VI, had first bought a corgi for Elizabeth and her sister, Princess Margaret, in 1933, a dog named Roszavel Golden Eagle but known as Dookie (the late Queen Mother's little joke—Dukie was Wallis Simpson's pet name for the Duke of Windsor). Susan, who accompanied Elizabeth and Prince Philip on their honeymoon, became the matriarch of the royal corgi dynasty that survives today, along with the well-known dorgis—a cross between Queen Elizabeth's corgi, Tiny, and the late Princess Margaret's dachshund, Pipkin. Until the corgis arrived, there had been no dog breed specifically associated with the monarchy, but corgis now became so fashionable that between 1934 and 1951 the British Kennel Club registrations rose from 240 to 4,595. Originally Welsh cattle dogs, corgis are known for their ankle-biting tendencies, and it is said that, unbeknownst to him, Queen Elizabeth once spotted a policeman surreptitiously kicking a corgi after he had been nipped; she sharply informed him that if he ever kicked a dog again, she would bite him too.

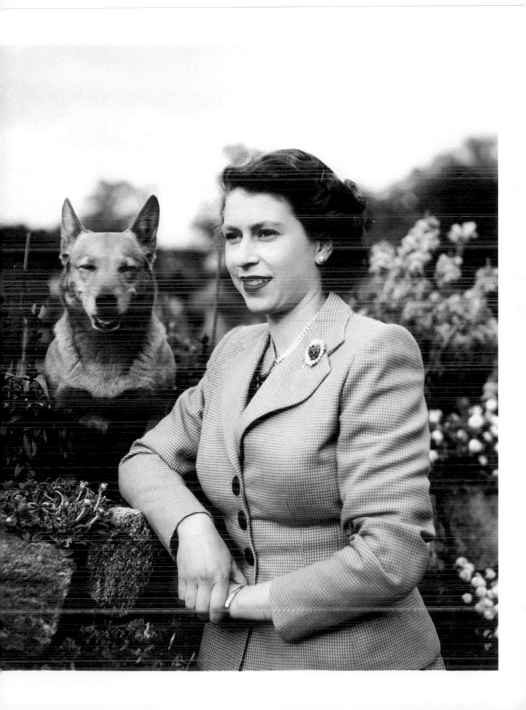

Dorothy Parker and her dachshund, **Robinson**, 1932

In one of her first articles for *Vogue*, in March 1917, Dorothy Parker (1893–1967), then Dorothy Rothschild, wrote about the fashionable dog in typical facetious style. "If it's the little things that count in life, one might acquire a Brussels griffon," she informed her readers. "They are scarcely visible to the naked eye. . . . No woman who owns a Pekingese can be accused of selfishness; she simply hasn't the time to think of herself." The writer and wit loved most animals, but it was dogs that she could not do without. When she married in 1917, she bought herself a Boston terrier, whom she named Woodrow Wilson (the then president), but she was too busy writing and partying with the Algonquin Round Tablers to housebreak him; so bad was the situation that the floorboards began to buckle. Her next dogs were Daisy, a Scottish terrier; Timothy, a Dandie Dinmont; and Robinson, the standard dachshund in this *Vanity Fair* portrait. Robinson, an aristocrat formally known as Eiko von Blutenburg, was accustomed to a diet of bratwurst, and scorned dog biscuits; he went everywhere with his mistress, from tea parties to speakeasies, where he would curl up and sleep under the table. When he died, the heartbroken Parker got two completely different dogs—Bedlingtons named Wolf and Cora—who drove across the country with her and Alan Campbell to their wedding in New Mexico. She and Campbell moved to Los Angeles, where people were less tolerant of her dogs than were New Yorkers. When one of the Bedlingtons pooped in the lobby of the Beverly Hills Hotel, the manager called out, "Miss Parker, Miss Parker! Look what your dog did." Giving him a gimlet look, she replied, "I did it." Dorothy Parker died in 1967, with her poodle, Troy, beside her.

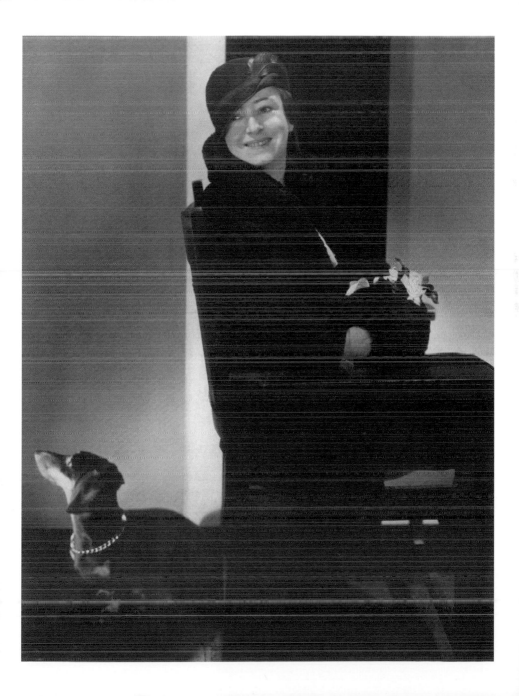

Georgia O'Keeffe and **Bo**, one of her chow chows, 1966

Cecil Beaton was commissioned by *Vogue* to photograph the American artist Georgia O'Keeffe (1887–1986) at her remote home in Abiquiu, New Mexico. On arrival, he was alarmed by signs warning of dangerous dogs; however, Bo and Chia, the chow chow puppies that greeted Beaton, behaved gently—although, O'Keeffe assured him, one of them had bitten her neighbor. Once inside the house, Beaton felt more comfortable: the walls were lined with skulls, antlers, and bones; the adobe dining room was a beautiful mushroom color; and photographing the artist, then age eighty-one, was a dream—it was quite impossible to take a bad photograph of her, he said. O'Keeffe was devoted to her chow chows, and wrote of how they astonished and amused her—Bo, lying on her window seat with his legs stretched out behind him "like a fine big cattapillar [*sic*]." They went on painting trips with her, they slept in her room at night, and she would brush their thick coats for them and had the hair woven into a shawl. Bo was the local canine alpha male and would wander out and have a fight when the mood took him, so he boasted some handsome scars as he grew older. When he died, O'Keeffe buried him under a cedar tree: "I like to think that probably he goes running and leaping through the White Hills alone in the night."

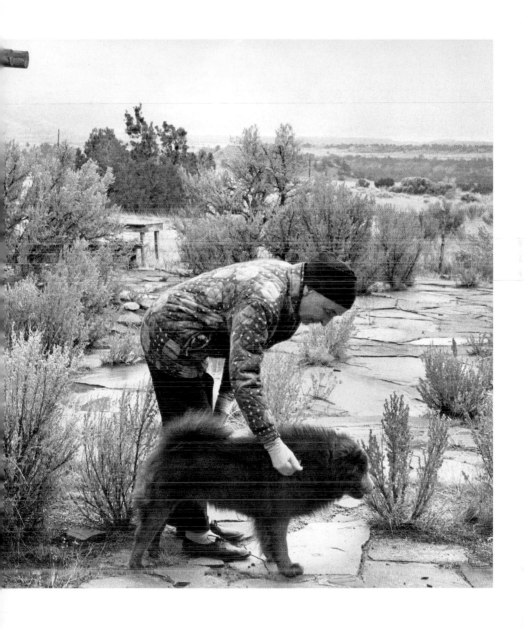

Martina Navratilova and **Judy Nelson** with their dogs, 1991

The Czech tennis ace Martina Navratilova (born 1956) was a record nine-time women's champion at Wimbledon, and four-time U.S. Open champion. She sought political asylum in the United States at age eighteen and became a U.S. citizen in 1981. Three years later, she came out as a lesbian, when she began a relationship with Texan Judy Nelson. They began a serious collection of dogs and are seen here surrounded by their Shiba Inus and a miniature schnauzer, with Navratilova clutching a Chihuahua. The couple separated after eight years together, Nelson demanding palimony. Navratilova has since acquired a number of delightful dogs, including KD the fox terrier, Sophie the Jack Russell terrier, Bina the Chihuahua, and two Boston terriers, Madison and Frodo. These dogs are very much part of her family, often mentioned by her in the media—and appear on her Web site. And Navratilova has influenced many other World Tennis Association players to keep dogs. At the Rogers AT&T Cup in Toronto in 2004, a note on the clubroom door read, "No Animals Allowed Unless in Bags." Present at the tournament had been "Sophie" Navratilova, "Patrick" Dementieva, and "Sam" Huber. Other regular dogs on the tennis circuit are the Williams sisters' terriers "Jackie" and "Bobby," "Ariel" Seles, and "Roland" Sanchez-Vicario.

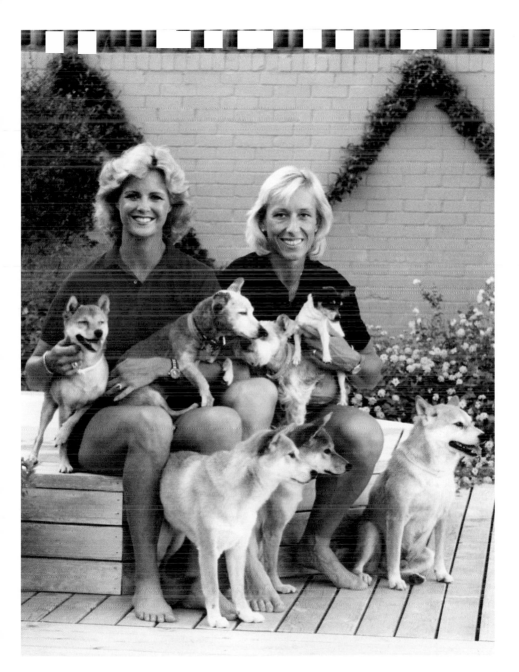

Beatrix Potter and Spot, the family's springer spaniel, 1882

For a century, Beatrix Potter (1866–1943) influenced children's attitudes toward animals—and indeed still does so today—with the *Tales* set in her beloved Lake District. Unlike her pet rat Sammy or her rabbit Peter, Spot the spaniel didn't appear in her stories, but he was Potter's first dog, and a source of enchantment. The family acquired him in Scotland, and he appears in a series of photographs of the young Beatrix in 1882. A springer spaniel, he had all the energy of the breed and a love of traveling in carriages; he once jumped into a carriage ahead of a line of women, such was his enthusiasm. Later, as a farmer, Beatrix Potter kept only working dogs and even her favorite collie, Kep, knew his place. However, in 1936 her cousin Stephanie introduced her to her Pekingese. Potter was scornful until she watched the dog climb Mount Hevellyn, whereupon she was converted. Two little "heathen Chinese," Tzusee and Chuleh, were acquired, and they were so adored that they were even allowed to sleep on the writer's bed.

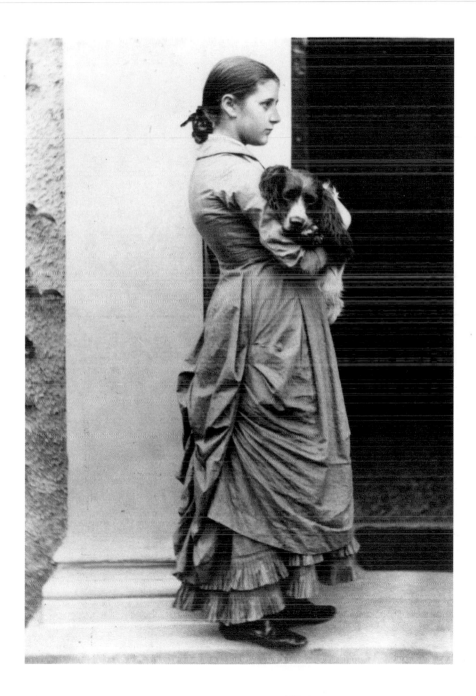

Renée Zellweger and her collie–golden retriever cross, **Dylan**, 1997

Actress Renée Zellweger (born 1969) and her dog Dylan (aka Woofer) were inseparable until his death in 2003. That year, when she was nominated for an Oscar for Best Actress for her role in *Chicago*, Zellweger missed the Miramax and *Vanity Fair* parties because she was at home looking after the ailing Dylan. The star is known for her lack of pretension, so this friendly collie–golden retriever cross, who accompanied her to work whenever possible, was a good choice. The two actually played alongside each other in the film *Nurse Betty*, with Dylan acting as a guide dog for the blind. Zellweger acquired Dylan when she was a student, in 1988. She had visited the Austin Animal Shelter with the aim of coming home with a cat. Instead, the puppy chose her, and selected its own name by spending two days sitting on Bob Dylan's face—on a cover of *Rolling Stone* magazine. After moving to Hollywood, Dylan and Zellweger eschewed the accoutrements of a fashionable movieland dog—no dog costumes or accessories for them.

Vita Sackville-West with **Rollo** the German shepherd, 1958

The author and gardener Vita Sackville-West (1892–1962)—sometime lover of Virginia Woolf and the model for Woolf's hero(ine) *Orlando*—is shown here in her garden at Sissinghurst Castle with Rollo, her last Alsatian (as she called German shepherds). He had joined her in 1948, taking the place of a beloved old predecessor, Martha. Like many dog lovers, Sackville-West had faced the difficulty of deciding when to acquire a replacement. She was offered Rollo before Martha's death but felt dreadfully disloyal accepting him: "When I send for it, it will mean that Martha is dead—killed by my orders," she wrote to her husband, Harold Nicolson. "You see, I am essentially a lonely person, and Martha has meant so much to me. She was always there, and I could tell her everything." Nonetheless, Rollo arrived the evening of Martha's death: "So soft and innocent and unaware of the blank that he is meant to fill." The Alsatians were lovingly commemorated in Sackville-West's *Faces: Profiles of Dogs*. There had been a number of previous dogs in her life, including a saluki that she bought as a present for Harold, who was then posted as a diplomat in Tehran. She acquired the saluki en route, in Iraq, enlisting the help of the archaeologist Gertrude Bell, who put the word out that she wanted one of these desert hounds. Soon a succession of Arabs arrived, leading a pack of flea-ridden dogs. Sackville-West wanted them all, but in the end she settled on a young bitch, "a marvel of elegance" whom she named Zurcha.

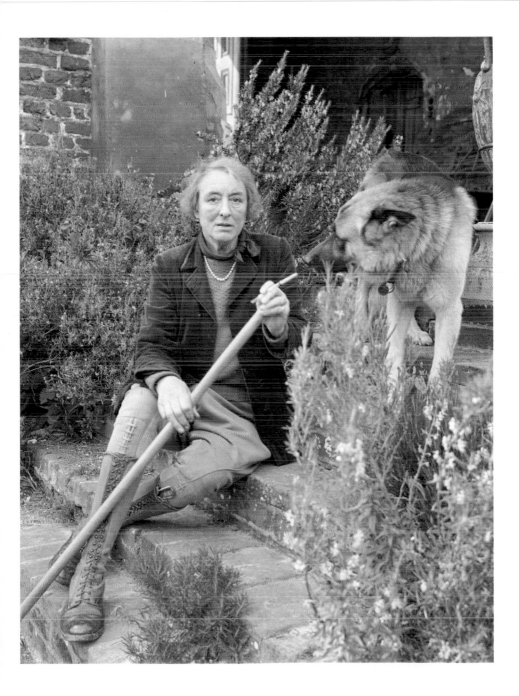

Jean Simmons with a white poodle, 1954

Jean Simmons (born 1929) was at the peak of her career at the time of this photo—probably taken at the Hollywood home she shared with her husband, Stewart Granger. The young British actress had been catapulted to critical acclaim as a teenager, playing the young Estella in David Lean's *Great Expectations* (1946), and she had consolidated her reputation as the young Elizabeth I, opposite Granger, in *Young Bess* (1953), released to coincide with the coronation of Elizabeth II. The latter role was a mixed blessing, as MGM then pushed her into a number of historical dramas, or, as Simmons put it, "What I call 'poker-up-the-ass' parts. You know, those long-suffering, decorative ladies." The following year, Simmons was featured in further photo stories with her pets—one in particular, shot by Sid Avery, showing her with two poodles, a Lhasa apso, and her Siamese cat—in what may have been a bid to promote a more accessible image prior to the release of the musical *Guys and Dolls* (1955), in which she played alongside Marlon Brando and Frank Sinatra.

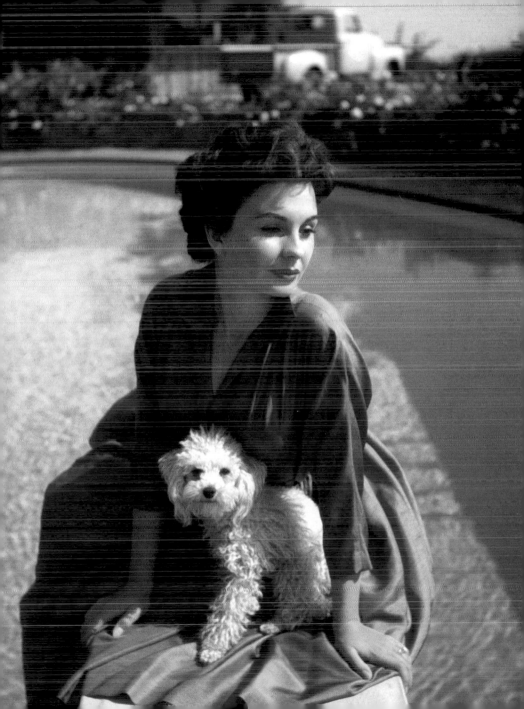

CZ Guest with some of her dogs: a Mexican hairless, a Great Dane, and a poodle, 1955

"There are blondes, and then there are blondes," wrote Raymond Chandler in *The Long Goodbye*. Truman Capote quoted this in 1975 to evoke his friend CZ Guest (1920–2003), recalling her "blanc de blanc perfection" when he first met her with Cecil Beaton at the opening of *My Fair Lady* in New York. Lucy Douglas Cochrane, as she then was—CZ or CeeZee derived from her little brother's pronunciation of "sissy"—was a Boston debutante with a passion for horses and dogs—and fun. She was an actress and showgirl for a while, running off to Mexico at twenty-two and posing nude for Diego Rivera. The painting was rumored to have hung above the bar at the Reforma Hotel in Mexico City. Then, at twenty-seven, tiring of bohemian life, she married the enormously eligible Winston Churchill Guest (an American relative of the British leader) in Havana, Ernest Hemingway acting as best man. Capote observed that she got what she wanted: a home, a husband, dogs, horses, and children —in that order. Staying at the Guests' Palm Beach home, Capote watched her each morning walking along the beach with her pack of dogs—"You never saw such a confoundingly assorted gang—the purest bred English mastiffs, mutts from the pound, Saluki, a golden Labrador with a blind patch over one eye, a fat peke huff-puffing to keep up, and everybody's particular buddy, a big-sized Mexican hairless abandoned in some godforsaken Mexican airport." When her husband's fortune started to dwindle, CZ began a career as a columnist at the *New York Post*, writing and lecturing on gardening. Her all-American style and exquisite good taste in dress, homes, and gardens made her an enduring icon and she appeared on the cover of *Time* magazine in 1962—alongside her saluki, of course.

Dodie Smith with her last Dalmatian, **Charley**, 1986

Dodie Smith (1896–1990), the author of *The Hundred and One Dalmatians*, kept Dalmatians throughout her life, as you would hope, and of course her novel and its Disney film enormously increased the popularity of the breed. At the beginning of the twentieth century, Dalmatians were still seen in their original role as carriage dogs, and in Britain a few eccentrics would have them running beside their bicycles or motorcars; only fifty-seven were registered at the Kennel Club in 1911. In 1937 Smith acquired her Dalmatian Pongo, the first of nine, and the following year, when she was an aspiring actress, she and the dog, and her manager (and future husband), Alec Beesley, moved to California. Ensconced in Beverly Hills, she gave up on acting ("I was too short," at five feet tall) and turned her hand to screenwriting for Paramount, while Beesley became a counselor for fellow conscientious objectors after America entered World War II in 1941. Smith had her break as a writer in 1949, with her million-selling novel *I Capture the Castle*, and in 1951 she, Alec, and their dogs returned to Britain. A chance remark in Hollywood, when a friend had suggested that the Dalmatian would make a nice fur coat, had stayed with her, and inspired her to write first a short story, and then the novel *The Hundred and One Dalmatians*, which was filmed by Disney in 1961. Its sequel, *The Starlight Barking*, in which Sirius comes to Earth to rescue all earthbound dogs, was published in 1967. Aptly, Smith's biographer, Valerie Grove, also has a Dalmatian, named Beezie, immortalized by Trevor Grove in his *One Dog and This Man*.

Gertrude Stein with Basket II, 1946

The American critic and writer Gertrude Stein (1874–1946) said that her first poodle, Basket, made her into a doggy person. This photograph by Horst shows her with Basket's successor, Basket II, at home in Paris, sitting in front of a portrait by Marie Laurencin of the first Basket. Stein and her partner, Alice B. Toklas, had bought Basket in 1928; Toklas had wanted a white standard poodle ever since reading Henry James's *The Princess Casamassima*. "He was a little puppy in a dog show and he had blue eyes, a pink nose and white hair and he jumped into Gertrude Stein's arms," wrote Stein. They had other dogs—two Chihuahuas named Byron and Pepe (a bit of a biter)—but Basket was special to Stein, and "listening to the rhythm of his water drinking made me recognize the difference between sentences and paragraphs, that paragraphs are emotional and that sentences are not." When the dog died in 1938, Picasso, who had designed needlepoint portraits of Basket for cushions, suggested that he get them an Afghan hound, like his adored Kazbek, but Stein and Toklas had their minds set on another poodle. "Baby Basket has lovely eyes so we feel that he is Basket's baby, and we feel so much better."

Serena Williams with her Jack Russell terrier, **Jackie**, 2002

Tennis champions Serena (born 1981) and Venus Williams are both devoted dog owners, and take their dogs around the circuit wherever possible. Venus has a Yorkshire terrier named Bobby, with whom she often celebrates a victory on the court. Serena, the younger sister by a year, got her Jack Russell terrier, Jackie, in 1999, the year she first won the U.S. Open. "I called her my lucky dog because I got her when I was in the second round. After that I went on to win," Williams explained. The next year she won Wimbledon. Serena Williams also has a pit bull terrier named Bambi, whom she calls her "son."

Edith Wharton with her two Pekingese, **Tooty** and **Linky**, 1915

Best-selling American novelist Edith Wharton (1862–1937), author of *The Age of Innocence* and many other novels, kept a string of dogs, starting out with a standard poodle named Mouton and the papillons Nicette, Mitou, and Moza. By 1905 the rare lion-dog from the recently sacked Imperial Palace in Peking had replaced papillons as the smartest ladies' dog in London, and Wharton, ever the social barometer, switched allegiance to Pekingese and here is holding two, most likely Tooty and Linky. Her love of dogs was not simply fashion, however, and is commemorated in the story "Kerfol," published the year after this photo, in which the ghosts of four dogs take a grisly revenge on the murderer of their mistress; one of them is an especially small Pekingese "sleevedog . . . very small and golden brown, with large eyes and a ruffled throat." After the death of Linky in 1937, Wharton wrote sadly to her godson Bill Tyler about the bond she had felt with dogs ever since she was a baby: "We really communicate with each other," she assured him, "and no one had such nice things to say as Linky."

The Duchess of Windsor with the **duke** and one of their pugs, 1967

Prior to meeting her third husband, the future Edward VIII, the American divorcée Wallis Simpson (1896–1986) was not known as a dog lover. Edward, however, was devoted to his two cairn terriers, Cora and Jaggs, and presented her with a cairn named Slipper. She adored the dog, which died from a snakebite in 1936, just before their wedding. Three more cairns followed and were the duke and duchess's companions in France, and in the Bahamas during the war. However, when the last of them, Preezie, died in 1949, the couple turned to pugs. This was part of their ongoing war with the Windsors: pugs were the royal dogs of Holland, and had been favorites of English royalty since the arrival in London of William of Orange in 1688. Through pugs, Wallis was asserting the Windsors' claim to be more royal than the real thing—all the more so since George VI had turned to "nouveau" corgis. To the childless Wallis and the duke, the pugs became a fetish, entered at dog shows (as in this photograph) and attending the dog parties then fashionable in Paris. The duchess often dressed them in wing collars and bow ties, and at their Paris home there were Meissen pugs, puggy *objets,* and pug cushions in abundance. Over the years, the couple kept nine pugs, including one called Peter Townsend (a riposte to the Queen Mother, who had called a corgi Dookie in mockery of Wallis's American endearment, "Dukie"). The duke died in 1972 with his favorite dog, Black Diamond, at his side. When the duchess herself became ill, she had to give her dogs away, as she couldn't bear the noise of their barking.

Katy England and her English bull terrier, **Mouse**, 1998

Katy England (born 1966), fashion editor of *Dazed & Confused* magazine and stylist for the designer Alexander McQueen, is one of the key image-makers in the fashion world, and a confirmed dog lover. She was brought up with a Staffordshire named Toby, who lived for sixteen years, but chose for herself an English bull terrier—because of bull terriers' beauty and because "they are more extreme." In 1997, England was single and wanted a dog to look after, so she and McQueen visited an acquaintance whose bull terrier, Bonnie, had a litter of puppies. The puppy England chose "was sitting on her own, pure white, a little bit shy," and Katy named her Mouse. McQueen also chose one, naming her Juice. Since then the dogs have become fashion personalities, and the November 1998 issue of *i-D* magazine featured a story by photographer Derrick Santini on the Bonnie dynasty. "Having Mouse is like having a child," says England, now a mother of two, "because she is sensitive and she gets depressed and she is so individual. She is also very stubborn and I have to say to her, 'Look, Mouse, I am the boss.' And I've never had a single doubt about her with the children. She fits in with their pace and is very maternal." Mouse now spends part of the year with England's parents, to have a country break. She and Juice, however, cordially loathe each other.

Unknown woman and dog in a Harlem window, 1943

The legendary Gordon Parks took this photograph of an anonymous woman in Harlem, New York City, in May 1943. Parks (born 1912), long recognized as one of America's foremost photographers, is also a writer, poet, composer, and film director, contributing greatly to the chronicling and recognition of black American cultures in the postwar United States. This picture—part of a project recording Harlem life—is nearly contemporary with his most famous image, *American Gothic*, of a cleaner standing in front of the American flag. Parks went on to work for *Vogue* and *Life* magazines, wrote the script and music for the film based on his novel *The Learning Tree*, and directed the films *Shaft* (1971) and *Leadbelly* (1976). "Photography enabled me to do all of those other things," he wrote. "I'm very thankful to photography. I have often said I tried to use it as a weapon against poverty, against racism, against bigotry, against anything that I disliked in this universe."

Tallulah Bankhead with two of her Pekingese, 1934

Tallulah Bankhead (1902–1968) once said, "Don't talk to me about camp, darling, I invented it!"—and camp she was, this outrageous, witty actress and openly bisexual diva. The scion of a famous political family from Alabama, she arrived in London in 1923 with knee-length blond hair to pursue a career on the stage. The hair was bobbed, she called everyone "daaahling" in a southern drawl, and she attracted a following of female fans who would attend her performances nightly. Bankhead so encapsulated the spirit of the Roaring Twenties that she starred as Iris Storm in Michael Arlen's *The Green Hat*. Her Pekingese Napoleon, also a blond, was almost as much of a celebrity, appearing with her in *The Cardboard Lover* (1924), in which a line about him was inserted. His likes and dislikes (his favorite tipple—Horlicks) were religiously noted by the press, and he shared Bankhead's Mayfair home with her kitten, Mussolini, carefully chosen to match the ivory tones of the flat. Bankhead returned to the United States at the outbreak of World War II, and settled in a New York country home, where the Pekes Maximilian, Sally Ann, and Brockie succeeded Napoleon, along with a poodle named Daisy, a Sealyham named Hitchcock (a gift of the director), and a Maltese named Dolores, not to mention a lion, monkeys, cats, and budgerigars. "I've been pet-drunk so long as I can remember," she explained.

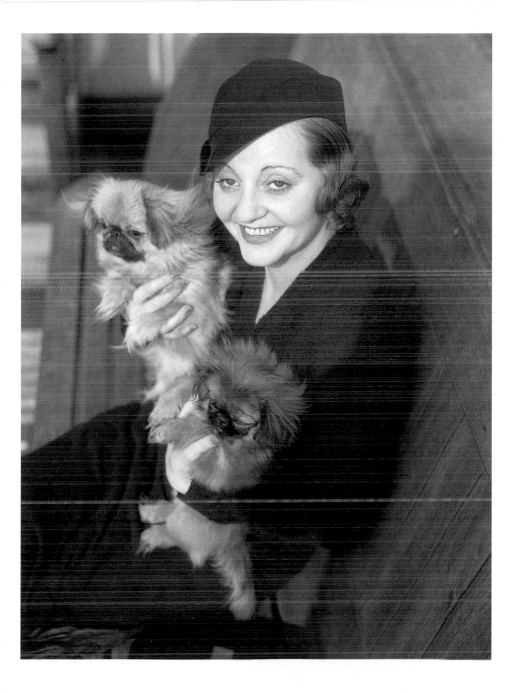

Sharon Osbourne with her family and her dogs, **Minnie**, **Lulu**, and **Martini**, 2002

The reality TV show *The Osbournes*, featuring heavy-metal rocker Ozzy Osbourne, his wife, Sharon (born 1952), and their two younger children, Kelly and Jack, at home in California, was compulsive viewing in large part on account of the ongoing relationship between the family and its pets: Lola the English bulldog, Minnie and Pipi the Pomeranians, two Japanese Chins named Maggie and Baby, the Chihuahuas Lulu and Martini, and a cat named Puss. The house was, in Ozzy's words, "Beverly Hills' most expensive sewer . . . a nine-million-dollar turd," and he forbade his animal-loving wife to bring home any more crap-dispensing animals from the local pet shop. Lola's habits in particular caused him pain: "I love Lola. Don't get me wrong; I really love Lola. What I don't like doing is picking . . . I don't mind a little f***ing Pomeranian turd, but when that f***ing bulldog unloads, you got to get an earth-mover and a f***ing gas mask to go in the kitchen, it's like f***ing plutonium turds." There was much disapproval among the dog-training fraternity about all these "dysfunctional" dogs—especially Minnie, Sharon's "top diva," who clearly realized that her fractious snapping at strangers on camera produced gales of affirming laughter. In the contract for the second season, Sharon Osbourne not only negotiated a fee of $20 million but also stipulated that MTV should pay for her dogs' therapy fees.

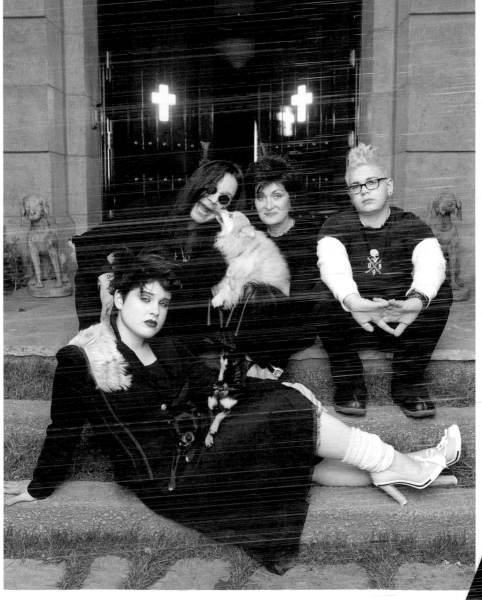

PICTURE CREDITS

All photos are copyright of the following picture libraries and photographers, and reprinted by permission:

abc press, Amsterdam: p. 59 (Coco Chanel).

akg-images: p. 43 (Josephine Baker); p. 63 (Colette); p. 149 (Edith Wharton).

Associated Press: pp. 48–49 (Germaine Greer), *Findlay Kember*; pp. 146–47 (Serena Williams), *Kathy Willens*.

Cecil Beaton Studio Archive, Sotheby's, London: p. 137 (Vita Sackville-West).

Camera Press, London: p. 54 (Barbara Cartland), *Snowdon/Vogue*; p. 115 (Sam Taylor-Wood), *Jonathan Player*; p. 119 (Hervey sisters), *Jillian Edelstein*; pp. 142–43 (Dodie Smith), *Jane Bown*; p. 153 (Katy England), *Derrick Santini*.

Center for Creative Photography, University of Arizona: p. 5 (Frida Kahlo), *Lola Alvarez Bravo*.

Condé Nast Publications Ltd: pp. 80–81 (Tania Mallet), *Vernier/Vogue*; p. 127 (Dorothy Parker), *Steichen/Vogue.*

Corbis: p. 11 (Radclyffe Hall); pp. 20–21 (Jacqueline Kennedy); p. 29 (Edith Cavell); pp. 34–35 (Anna Magnani); p. 37 (Barbara Woodhouse); p. 39 (Lauren Bacall); pp. 44–45 (Emmanuelle Béart); p. 51 (Clara Bow); p. 69 (Felicity Huffman), *Christopher Ameruoso/Corbis Outline*; p. 75 (Princess Alexandra); pp. 76–77 (Elizabeth Taylor); p. 79 (Dolores Del Rio); p. 87 (Jean Harlow); p. 91 (Olivia de Havilland); p. 101 (Grace Kelly); pp. 102–103 (Charlize Theron); p. 109 (Helen Keller); p. 117 (Evalyn Walsh MacLean); pp. 124–25 (Queen Elizabeth II); pp. 128–29 (Georgia O'Keeffe); pp. 150–51 (Duchess of Windsor); p. 155 (Harlem); p. 157 (Tallulah Bankhead); inside front cover (Jane Birkin), *Gabrielle Crawford*.

Lee Friedlander, courtesy Fraenkel Gallery, San Francisco: p. 25 (Storyville prostitute), *Bellocq*.

Getty-Images (including Hulton Archive): pp. 8–9 (Rita Hayworth); p. 23 (Queen Victoria); pp. 60–61 (Enid Blyton); pp. 70–71 (Joan Collins); p. 73 (Bette Davis); p. 83 (Ava Gardner); p. 95 (Lady Aberdeen); p. 97 (Edie Falco); pp. 98–99 (Jayne Mansfield); p. 105 (Billie Holiday); p. 121 (Mistinguett); pp. 138–39 (Jean Simmons); pp. 140–41 (CZ Guest).

Ellen Graham: p. 85 (Doris Day), from her book *The Bad and the Beautiful* (Harry N. Abrams).

Horst Estate: p. 145 (Gertrude Stein).

Katz: p. 107 (Tama Janowitz), *Mike Persson.*

Magnum photos: p. 30 (Indira Gandhi), *Marilyn Silverstone*; p. 67 (Joan Crawford), *Eve Arnold*; pp. 92–93 (Audrey Hepburn), *Dennis Stock*; p. 113 (Peggy Guggenheim), *David Seymour.*

National Gallery, London: p. 123 (Virginia and Leonard Woolf), *Gisèle Freund.*

Popperfoto: p. 133 (Beatrix Potter).

Retna: p. 89 (Debbie Harry), *Alice Arnold*; p. 159 (The Osbournes), *Stewart Volland.*

Rex Features: p. 7 (Ingrid Bergman), *Snap*; p. 13 (Sarah Jessica Parker), *Thomas Dallal*; p. 15 (Marilyn Monroe), *Sam Shaw*; pp. 26–27 (Janis Joplin), *Fotos International*; p. 33 (Maria Callas), *Sipa Press*; p. 41 (Madonna), *Steve Wood*; pp. 52–53 (Eleanor Bron), *Emilio Lari*; p. 65 (Jilly Cooper), *Tony Buckingham*; p. 111 (Jodie Kidd), *Steve Dutton*; p. 131 (Martina Navratilova and Judy Nelson), *Sipa Press*; p. 135 (Renée Zellweger); inside back cover (Natalie Wood).

The Royal Library, Copenhagen: p. 47 (Karen Blixen).

Time and Life: p. 19 (Veronica Lake), *Bob Landry.*

Philip H. Ward Collection, Rare Book and Manuscript Library, University of Pennsylvania: pp. 16–17 (Sarah Bernhardt); p. 57 (Mrs. Patrick Campbell).

SOURCES

I have made use of numerous biographies, autobiographies, reference works, and interviews, in books and online, in researching this book. Invaluable sources have included:

Traphes Bryant with Frances Spatz Leighton, *Dog Days at the White House*, 1975.

Herbert Compton (ed.), *The Twentieth Century Dog*, Vols. I and II, 1904.

[...] Cooper, *Animals in War*, 1983.

[...] Dangerfield, *Your Poodle and Mine*, 1954.

[...] Dale-Green, *Dog*, 1966.

Dictionary of National Biography, 2004.

Marjorie Garber, *Dog Love*, 1997.

Christopher Hawtree, *The Literary Companion to Dogs*, 1993.

R. Leighton, *The New Book of the Dog*, 1907.

Konrad Lorenz, *Man Meets Dog*, 1953.

K. MacDonough, *Reigning Cats and Dogs: A History of Pets at Court Since the Renaissance*, 1999.

B. Vesey-Fitzgerald, *The Book of the Dog*, 1948.

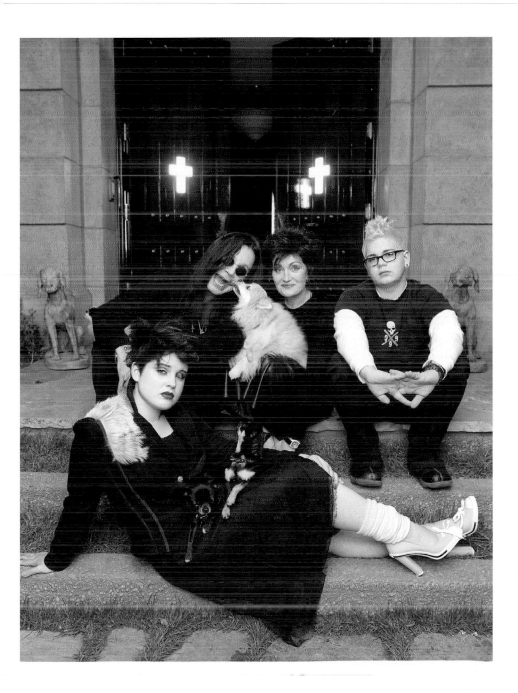

PICTURE CREDITS

All photos are copyright of the following picture libraries and photographers, and reprinted by permission:

abc press, Amsterdam: p. 59 (Coco Chanel).

akg-images: p. 43 (Josephine Baker); p. 63 (Colette); p. 149 (Edith Wharton).

Associated Press: pp. 48–49 (Germaine Greer), *Findlay Kember*; pp. 146–47 (Serena Williams), *Kathy Willens*.

Cecil Beaton Studio Archive, Sotheby's, London: p. 137 (Vita Sackville-West).

Camera Press, London: p. 54 (Barbara Cartland), *Snowdon/Vogue*; p. 115 (Sam Taylor-Wood), *Jonathan Player;* p. 119 (Hervey sisters), *Jillian Edelstein;* pp. 142–43 (Dodie Smith), *Jane Bown;* p. 153 (Katy England), *Derrick Santini.*

Center for Creative Photography, University of Arizona: p. 5 (Frida Kahlo), *Lola Alvarez Bravo.*

Condé Nast Publications Ltd: pp. 80–81 (Tania Mallet), *Vernier/Vogue;* p. 127 (Dorothy Parker), *Steichen/Vogue.*

Corbis: p. 11 (Radclyffe Hall); pp. 20–21 (Jacqueline Kennedy); p. 29 (Edith Cavell); pp. 34–35 (Anna Magnani); p. 37 (Barbara Woodhouse); p. 39 (Lauren Bacall); pp. 44–45 (Emmanuelle Béart); p. 51 (Clara Bow); p. 69 (Felicity Huffman), *Christopher Ameruoso/Corbis Outline;* p. 75 (Princess Alexandra); pp. 76–77 (Elizabeth Taylor); p. 79 (Dolores Del Rio); p. 87 (Jean Harlow); p. 91 (Olivia de Havilland); p. 101 (Grace Kelly); pp. 102–103 (Charlize Theron); p. 109 (Helen Keller); p. 117 (Evalyn Walsh MacLean); pp. 124–25 (Queen Elizabeth II); pp. 128–29 (Georgia O'Keeffe); pp. 150–51 (Duchess of Windsor); p. 155 (Harlem); p. 157 (Tallulah Bankhead); inside front cover (Jane Birkin), *Gabrielle Crawford.*

Lee Friedlander, courtesy Fraenkel Gallery, San Francisco: p. 25 (Storyville prostitute), *Bellocq.*

Getty-Images (including Hulton Archive): pp. 8–9 (Rita Hayworth); p. 23 (Queen Victoria); pp. 60–61 (Enid Blyton); pp. 70–71 (Joan Collins); p. 73 (Bette Davis); p. 83 (Ava Gardner); p. 95 (Lady Aberdeen); p. 97 (Edie Falco); pp. 98–99 (Jayne Mansfield); p. 105 (Billie Holiday); p. 121 (Mistinguett); pp. 138–39 (Jean Simmons); pp. 140–41 (CZ Guest).

Ellen Graham: p. 85 (Doris Day), from her book *The Bad and the Beautiful* (Harry N. Abrams).

Horst Estate: p. 145 (Gertrude Stein).

Katz: p. 107 (Tama Janowitz), *Mike Persson.*

Magnum photos: p. 30 (Indira Gandhi), *Marilyn Silverstone;* p. 67 (Joan Crawford), *Eve Arnold;* pp. 92–93 (Audrey Hepburn), *Dennis Stock;* p. 113 (Peggy Guggenheim), *David Seymour.*

National Gallery, London: p. 123 (Virginia and Leonard Woolf), *Gisèle Freund.*

Popperfoto: p. 133 (Beatrix Potter).

Retna: p. 89 (Debbie Harry), *Alice Arnold;* p. 159 (The Osbournes), *Stewart Volland.*

Rex Features: p. 7 (Ingrid Bergman), *Snap;* p. 13 (Sarah Jessica Parker), *Thomas Dallal;* p. 15 (Marilyn Monroe), *Sam Shaw;* pp. 26–27 (Janis Joplin), *Fotos International;* p. 33 (Maria Callas), *Sipa Press;* p. 41 (Madonna), *Steve Wood;* pp. 52–53 (Eleanor Bron), *Emilio Lari;* p. 65 (Jilly Cooper), *Tony Buckingham;* p. 111 (Jodie Kidd), *Steve Dutton;* p. 131 (Martina Navratilova and Judy Nelson), *Sipa Press;* p. 135 (Renée Zellweger); inside back cover (Natalie Wood).

The Royal Library, Copenhagen: p. 47 (Karen Blixen).

Time and Life: p. 19 (Veronica Lake), *Bob Landry.*

Philip H. Ward Collection, Rare Book and Manuscript Library, University of Pennsylvania: pp. 16–17 (Sarah Bernhardt); p. 57 (Mrs. Patrick Campbell).

SOURCES

I have made use of numerous biographies, autobiographies, reference works, and interviews, in books and online, in researching this book. Invaluable sources have included:

Traphes Bryant with Frances Spatz Leighton, *Dog Days at the White House,* 1975.

Herbert Compton (ed.), *The Twentieth Century Dog,* Vols. I and II, 1904.

Jilly Cooper, *Animals in War,* 1983.

Stanley Dangerfield, *Your Poodle and Mine,* 1954.

Patricia Dale-Green, *Dog,* 1966.

Dictionary of National Biography, 2004.

Marjorie Garber, *Dog Love,* 1997.

Christopher Hawtree, *The Literary Companion to Dogs,* 1993.

R. Leighton, *The New Book of the Dog,* 1907.

Konrad Lorenz, *Man Meets Dog,* 1953.

K. MacDonough, *Reigning Cats and Dogs: A History of Pets at Court Since the Renaissance,* 1999.

B. Vesey-Fitzgerald, *The Book of the Dog,* 1948.